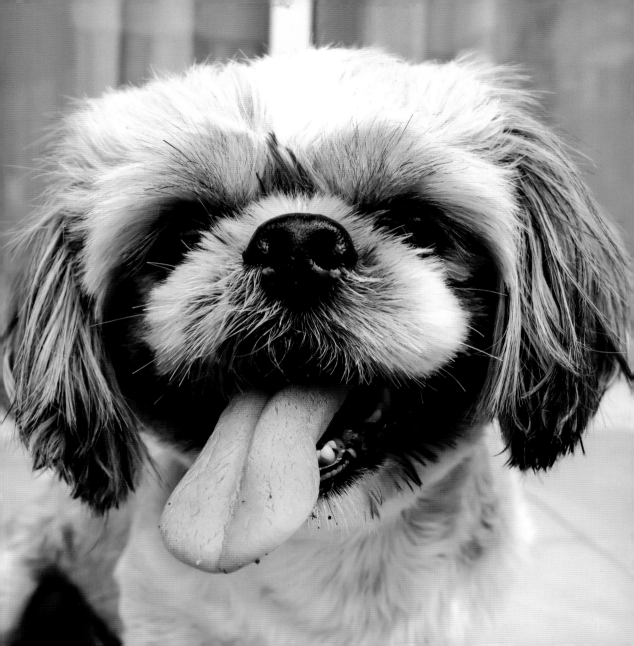

FOR DARCIE, MY FIRST AND FOREVER PUPPY

Published by Familius LLC, www.familius.com

Familius books are available at special discounts for bulk purchases,
whether for sales promotions or for family or corporate use. For more information,
contact Familius Sales at 559-876-2170 or email orders@familius.com.

Library of Congress Control Number: 2020939138
ISBN 9781641702935

Edited by Julia Levitan and Sarah Echard
Cover design by Carlos Guerrero
Book design by Mara Harris
Special thanks to our Twitter guest photographers: @darciedog (page 9), @abbey_and_zeus (page 25),
@busybodybiscuit (page 27), @brucethefrenchbully (page 31), @missmiau (page 50),
@mars.oli (page 54), @shandandherdogs (page 59), @jasperthecowdog (page 62),
@meet_lincoln (page 104), @captain_shark (page 114), @love.a.bull_diesel (page 118),
@mylittle.cricket (page 126), @korra_the_chibi_shibe (page 130).
All photographs copyright © 2017 by their respective owners.
All other photographs and vector elements licensed from Shutterstock.com.

10 9 8 7 6 5 4 3 2 1

First Edition

Printed in China

ERIKA SARGENT

DOGS WILL BE DOGS

THE ULTIMATE DOG QUOTEBOOK

FAMILIUS

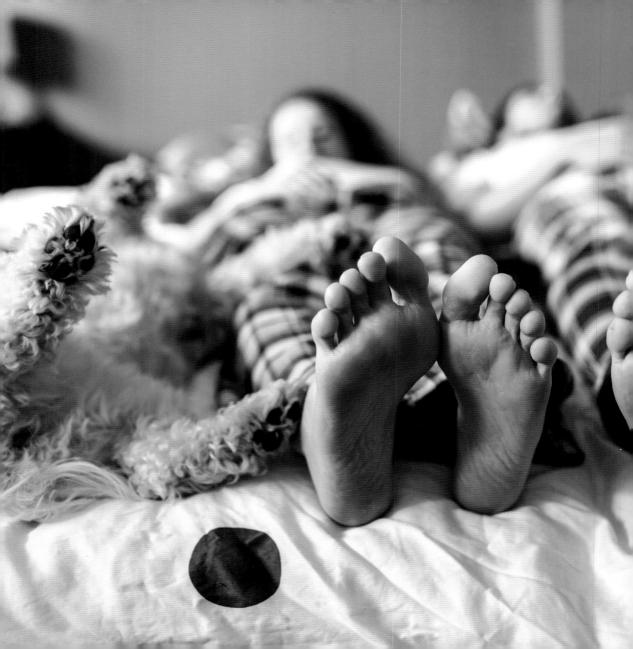

CONTENTS

INTRODUCTION

Did you ever want something so badly as a child that you begged your parents for it, wrote Santa for it, and wished for it every year as you blew out your birthday candles? That was me. And the something I wanted so badly was a dog.

Growing up as the middle child (the third of five), there was no shortage of noise, mess, and trouble to get into (at least according to my parents). But for me, a part of our family always seemed to be missing. Sure, we had fish and the occasional mouse or hamster as pets, but it wasn't the same. I wanted a pet I could interact with. With a dog, you can play at the park, dress up, and share popcorn as you watch TV together. A dog is more than just a pet. It's a part of the family.

It wasn't until I was twenty-five that my dream of becoming a dog mom came true. After short-listing *Petfinder* and visiting a number of animal shelters, I came across a kennel at Dallas Animal Services labeled "Husky

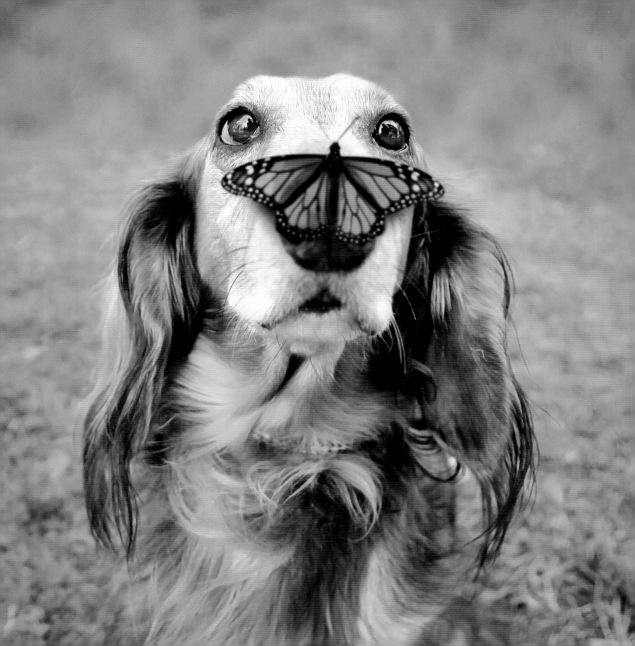

Mix." Inside was a tan-and-white puppy leaning against the glass door. When we walked by the kennel, "Husky Mix" looked up with her one brown eye/one blue eye and wagged her dipstick tail, and I was smitten on the spot.

We renamed her Darcie, and she is everything I begged and wished for. We play at the park, I dress her up every Halloween, and we binge watch *Friends* reruns with a bowl of popcorn between us. She's more than just a pet. She's a comforter, snuggle buddy, exercise enthusiast, protector, comedian, foot warmer, and so much more. She has filled a void in my life and become the family member I've waited so long to love.

"There is nothing truer in this world than the love of a good dog."

—MIRA GRANT, AUTHOR

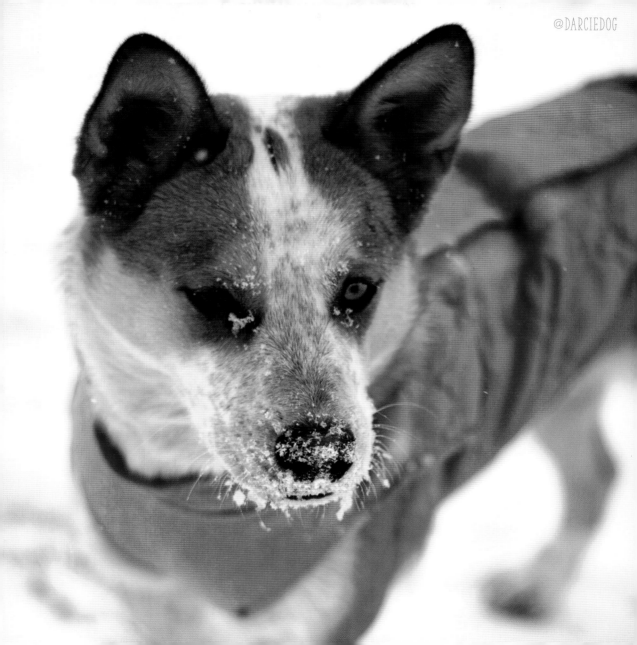

PUPPY LOVE

There's a reason that young love and infatuation have been characterized as "puppy love." Snuggle or play with one, and you'll understand that there's nothing that gives you a rush of instant adoration like a warm and wriggling puppy. Between their tiny tongues and their too-big-for-their-bodies paws, the clumsy way they run, and the way they always seem to be smiling, puppies are the embodiment of happiness.

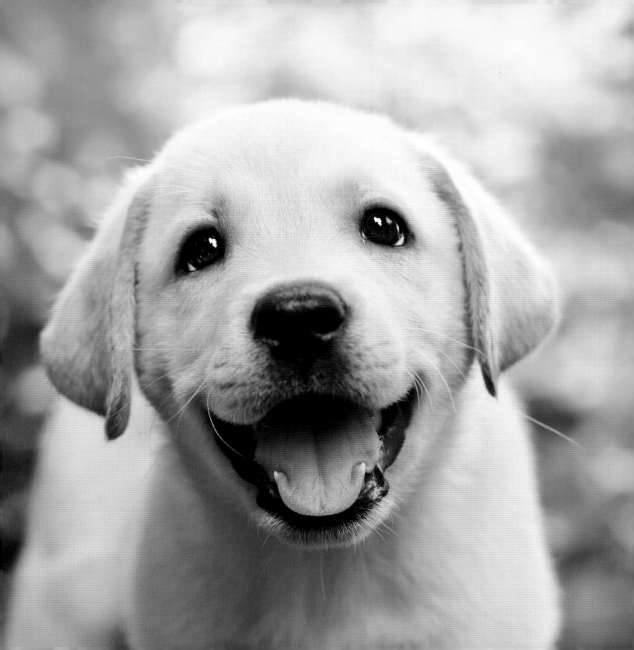

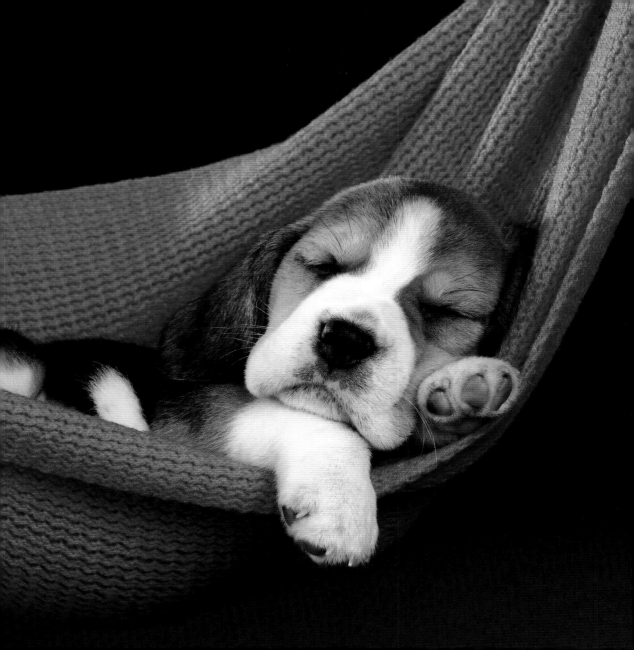

HAPPINESS
IS A WARM
PUPPY.

-CHARLES M. SCHULZ, CARTOONIST

I'M CONVINCED THAT PETTING A PUPPY IS

good luck.

—MEG DONOHUE, NOVELIST

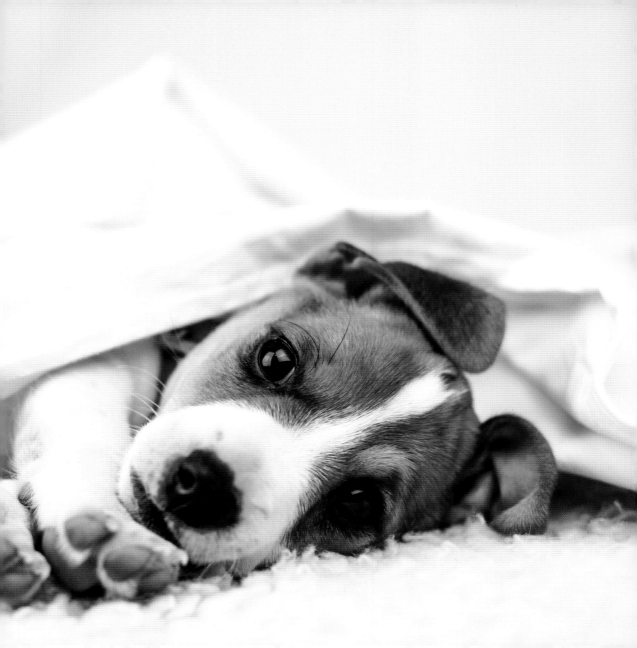

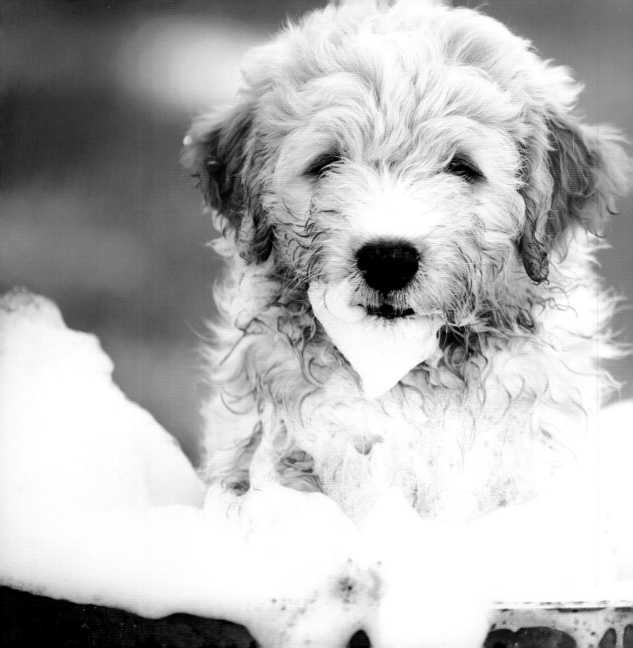

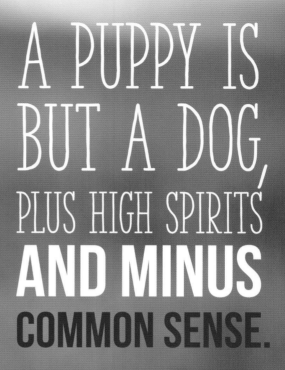

A PUPPY IS BUT A DOG, PLUS HIGH SPIRITS AND MINUS COMMON SENSE.

–AGNES REPPLIER, ESSAYIST

There is no psychiatrist in the world like a puppy licking your face.

-SIR BERNARD WILLIAMS, PHILOSOPHER AND WRITER

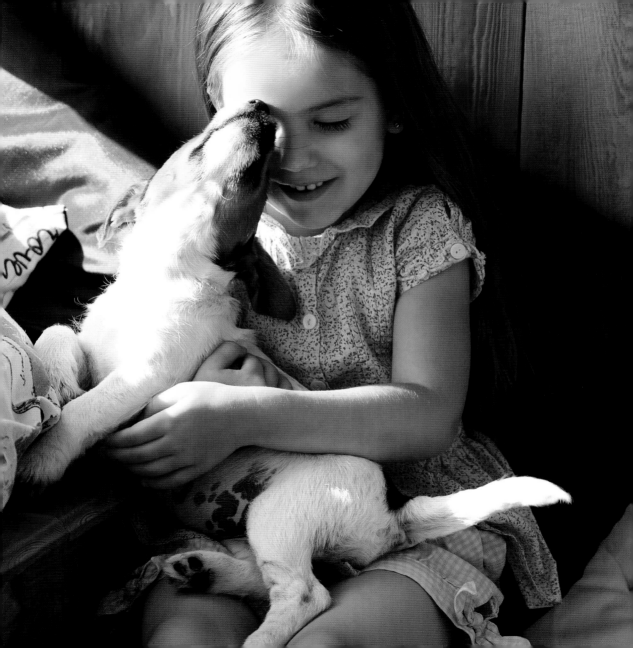

WHOEVER SAID
YOU CAN'T
BUY HAPPINESS
FORGOT
LITTLE
PUPPIES.

-GENE HILL,
AUTHOR AND OUTDOORSMAN

No symphony orchestra ever played music like a two-year-old girl laughing with a puppy.

-SIR BERNARD WILLIAMS,
PHILOSOPHER AND WRITER

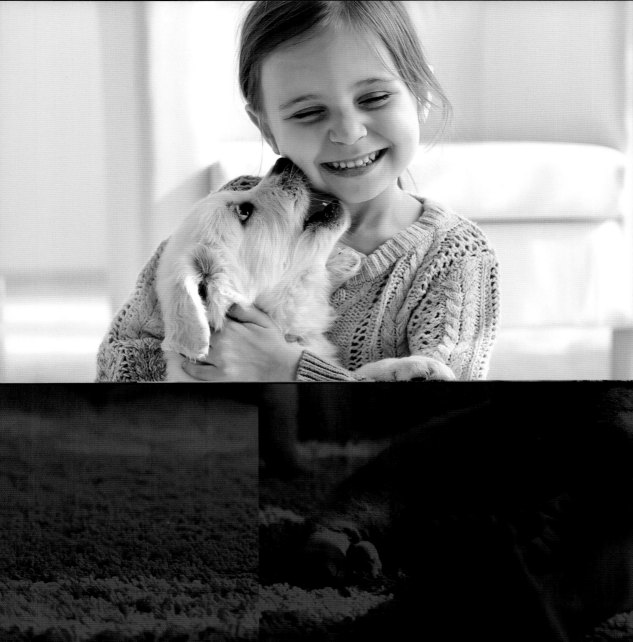

FUR BABIES

When you first get a dog, you might be under the impression that you're bringing home a pet. You might think that your new dog will learn to adapt to your personality, rambunctious kids, and rules of the house.

Give it a little time, and you'll soon realize that the dog you brought home is not a pet; it's family. Your little (or big) bundle of joy will teach you to adapt *your* lifestyle to *their* personality. They'll be the one riling up your rambunctious kids, actually helping them dig up earthworms in the backyard. And as for rules? Well, I have yet to meet someone who can say no to puppy-dog eyes.

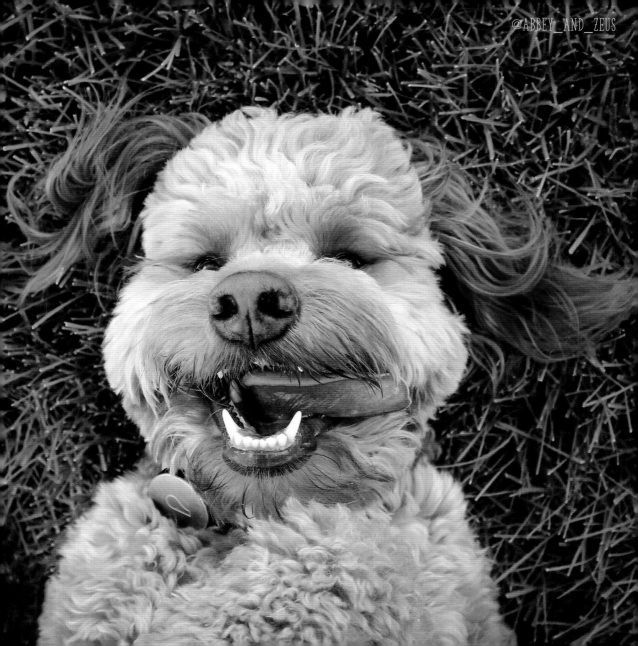

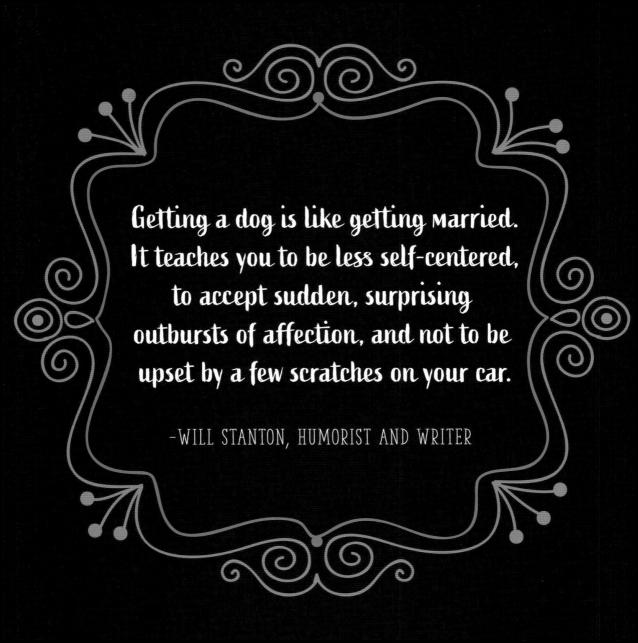

Getting a dog is like getting married. It teaches you to be less self-centered, to accept sudden, surprising outbursts of affection, and not to be upset by a few scratches on your car.

-WILL STANTON, HUMORIST AND WRITER

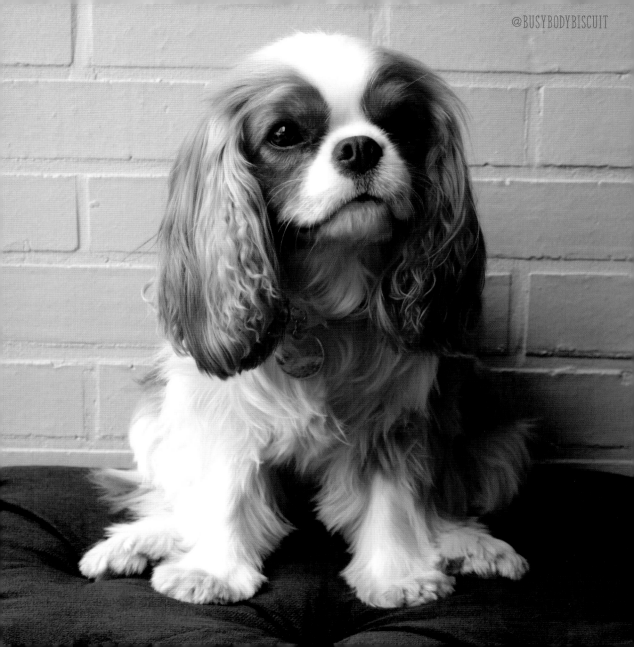

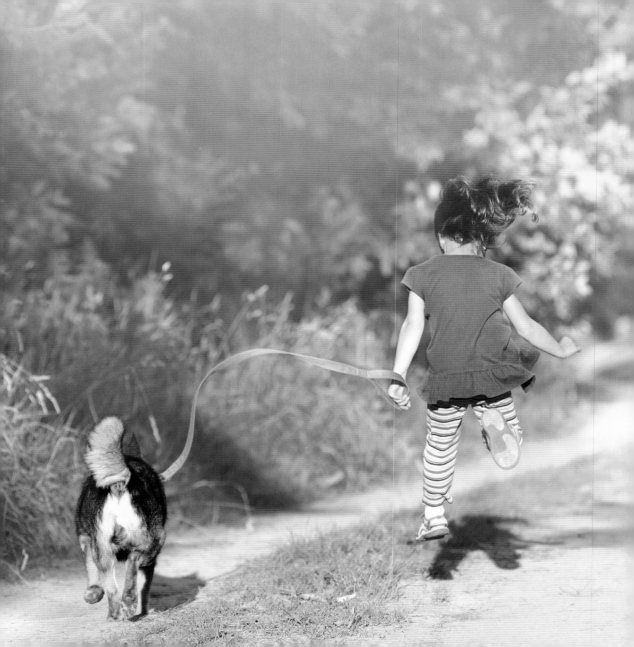

CHILDREN AND DOGS
ARE AS NECESSARY
TO THE WELFARE
OF THE COUNTRY
AS WALL STREET
AND THE RAILROADS.

-HARRY S. TRUMAN, UNITED STATES PRESIDENT

WHEN YOUR CHILDREN ARE TEENAGERS, IT'S IMPORTANT TO HAVE A DOG SO THAT **someone** IN THE HOUSE IS HAPPY TO SEE YOU.

-MEG DONOHUE, NOVELIST

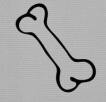

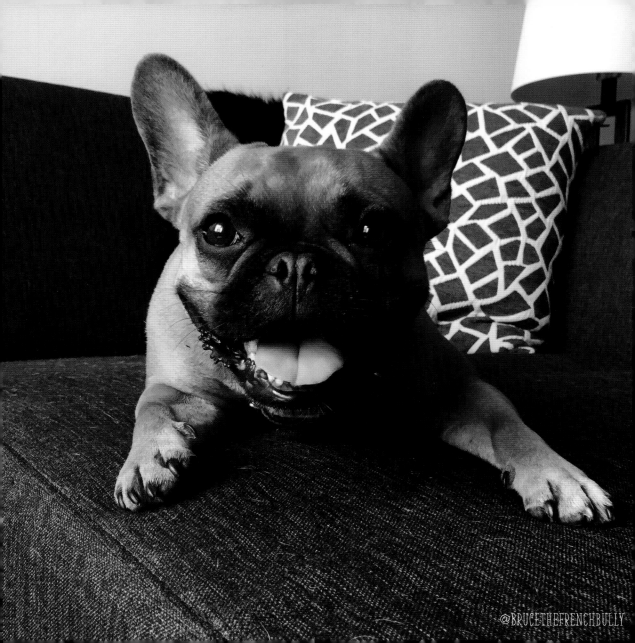

MY FASHION PHILOSOPHY IS,
IF YOU'RE NOT COVERED
IN DOG HAIR,
YOUR LIFE IS EMPTY.

-ELAYNE BOOSLER, COMEDIAN AND ANIMAL RESCUER

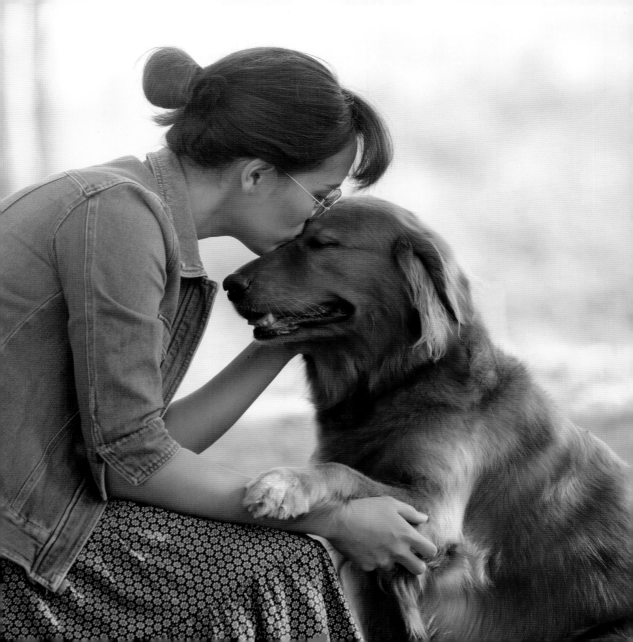

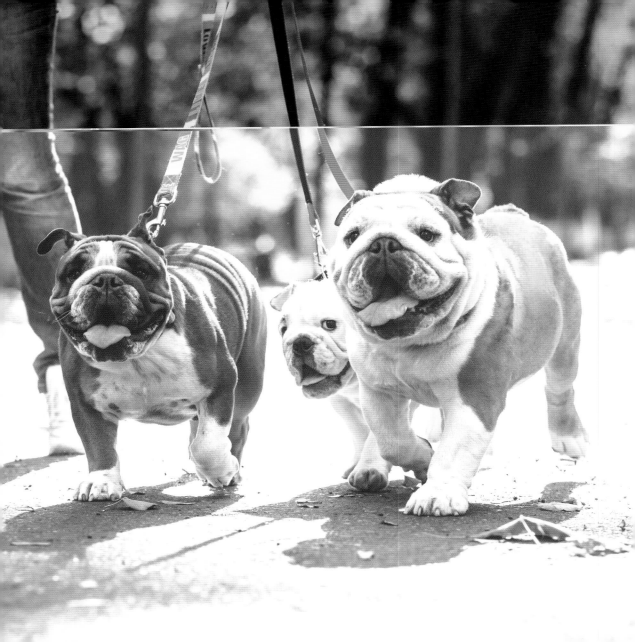

A DOG IS LIKE A PERSON—

HE NEEDS A JOB AND A FAMILY TO BE WHAT HE'S MEANT TO BE.

-ANDREW VACHSS, AUTHOR AND ATTORNEY

IF YOU WANT THE BEST SEAT IN THE HOUSE...

move the dog.

-UNKNOWN

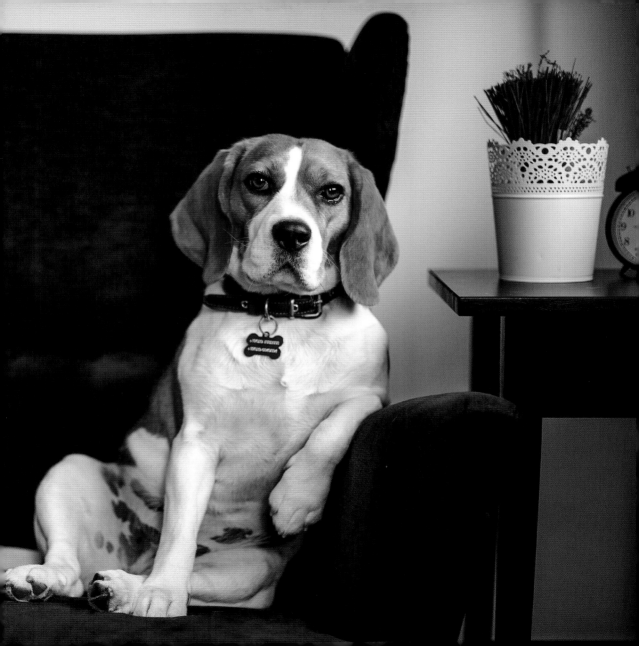

BIG 'N' SMALL

Everyone loves a puppy, but when they grow up into dogs, that's when people start to pick favorites. Do you like dogs that are big enough to ride or small enough to fit in your bag? Dogs that are short-haired or shaggy? Dogs that are purebred and pedigreed or mutts and mixes?

Dogs come in all shapes, sizes, colors, and breeds, but despite physical appearances, every dog has the same ability to love and be loved unconditionally.

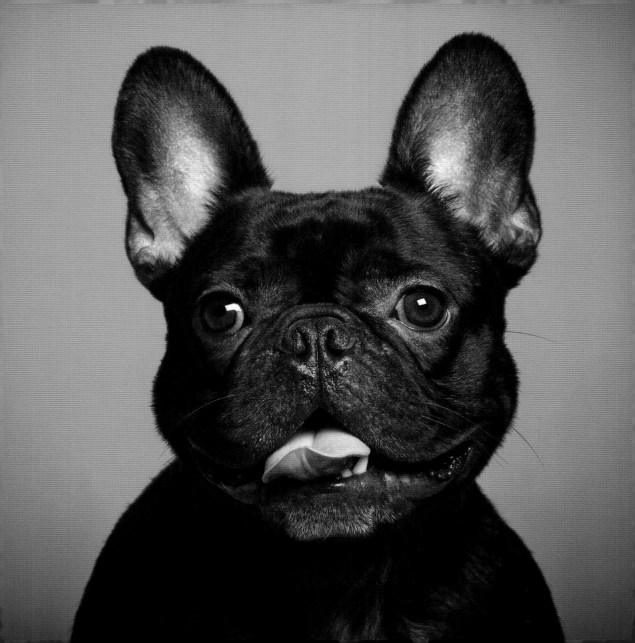

MY LITTLE OLD DOG: a heartbeat AT MY FEET.

-EDITH WHARTON, AUTHOR

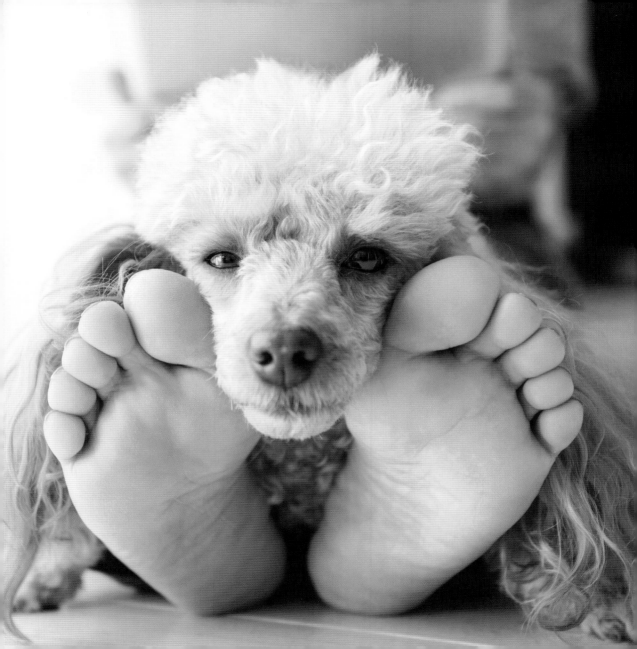

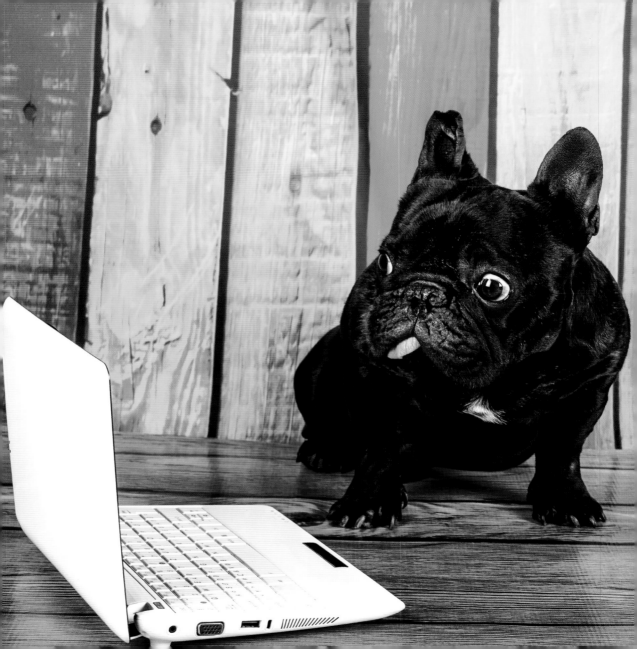

DOG'S GOT
PERSONALITY
PERSONALITY GOES
A LONG WAY.

-QUENTIN TARANTINO, FILMMAKER
PULP FICTION

WHEN AN EIGHTY-FIVE POUND MAMMAL
LICKS YOUR TEARS AWAY,
THEN TRIES TO
SIT ON YOUR LAP,
IT'S HARD TO FEEL SAD.

-KRISTAN HIGGINS, AUTHOR

EVEN THE TINIEST POODLE
IS LIONHEARTED,
READY TO DO ANYTHING
TO DEFEND
HOME, MASTER,
AND MISTRESS.

–LOUIS SABIN, AUTHOR

WHAT COUNTS
IS NOT NECESSARILY THE SIZE OF THE DOG
IN THE FIGHT –
IT'S THE SIZE OF
THE FIGHT IN THE DOG.

-DWIGHT D. EISENHOWER,
ARMY GENERAL AND UNITED STATES PRESIDENT

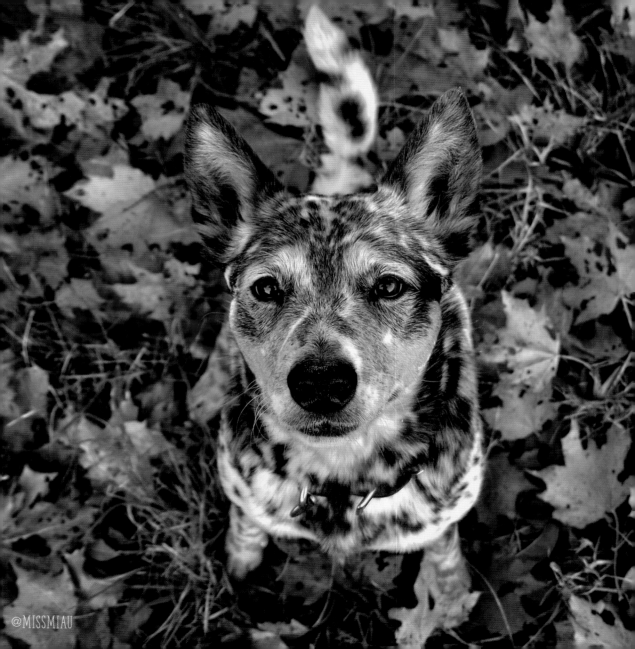

Everyone thinks

THEY HAVE THE BEST DOG.
AND NONE OF THEM
ARE WRONG.

—ANONYMOUS

HUMAN'S BEST FRIEND

What are the qualities that you look for in a friend? How about someone who is dependable, honest, a good listener, and able to cheer you up after a long day? Or perhaps someone who loves you despite your flaws, who is always ready for a spontaneous beach trip, and who is more than happy to sit on the couch with you for a fourteen-hour Netflix marathon?

Chances are your dog fits all of these qualities. For dogs, our happiness is their happiness, and that's the truest form of friendship.

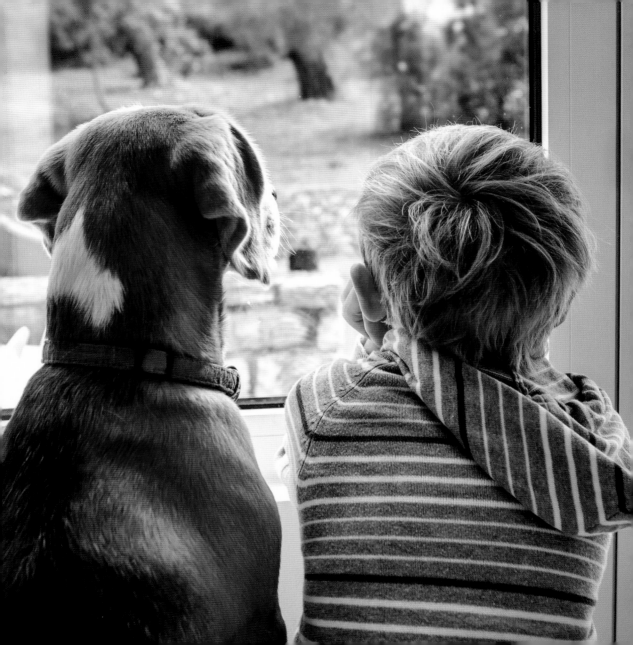

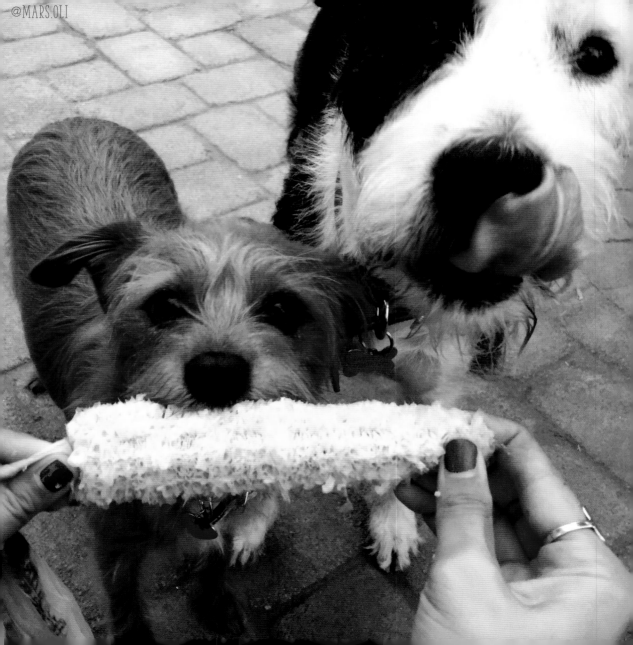
@MARS.OLI

WHEN MOST OF US TALK TO OUR DOGS, WE TEND TO FORGET they're not people.

-JULIA GLASS, AUTHOR

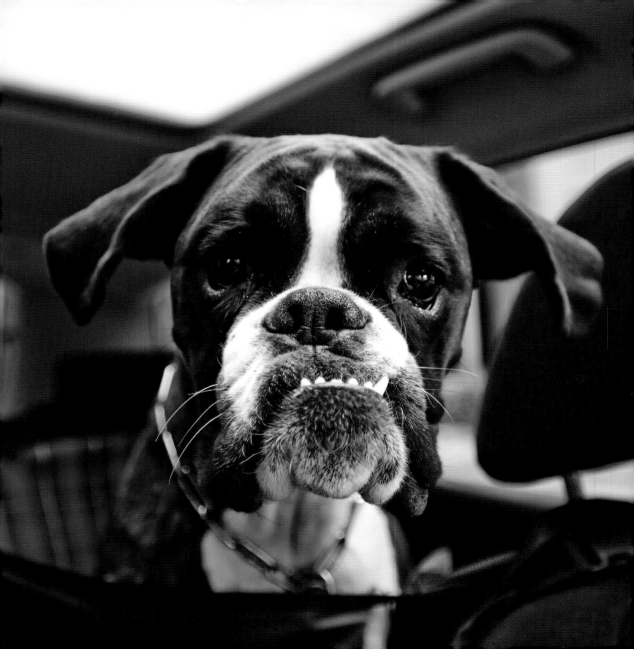

THORNS MAY HURT YOU,
MEN DESERT YOU,
SUNLIGHT TURN TO FOG;
BUT YOU'RE NEVER
FRIENDLESS EVER,
IF YOU HAVE A DOG.

-DOUGLAS MALLOCH, POET

DOGS ARE NOT OUR WHOLE LIFE, BUT THEY MAKE OUR LIVES WHOLE.

-ROGER CARAS, AUTHOR AND ANIMAL RIGHTS ACTIVIST

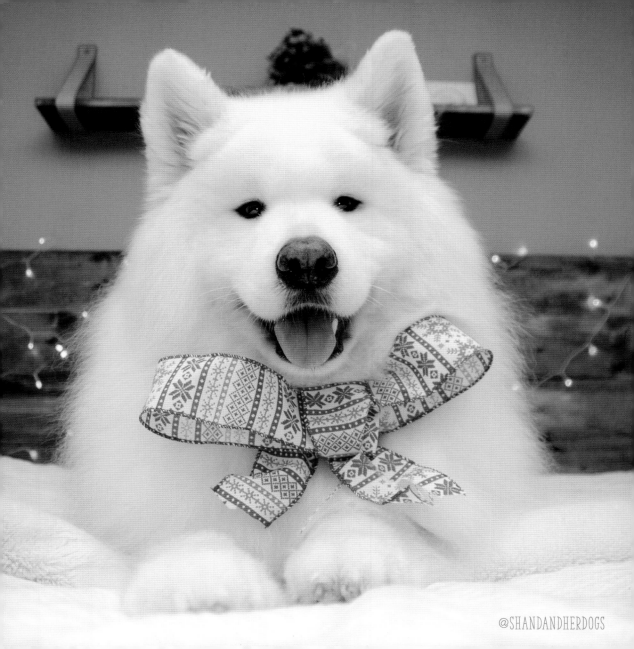
@SHANDANDHERDOGS

BE THE PERSON YOUR DOG THINKS **YOU ARE.**

-UNKNOWN

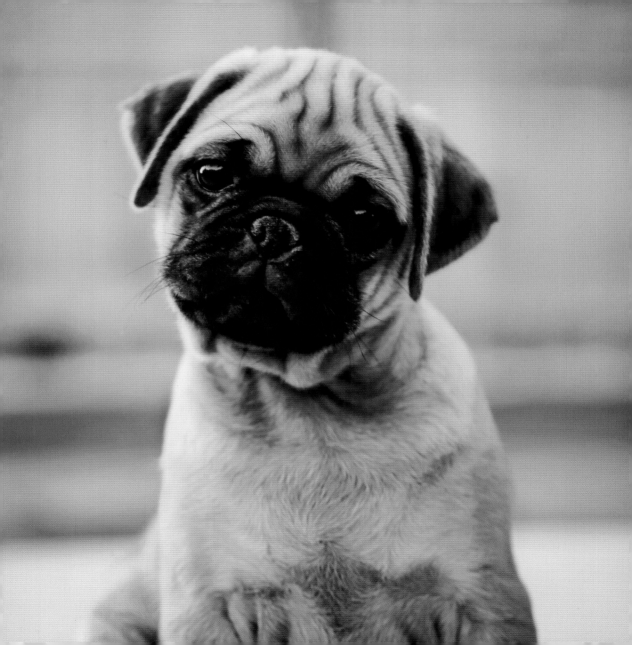

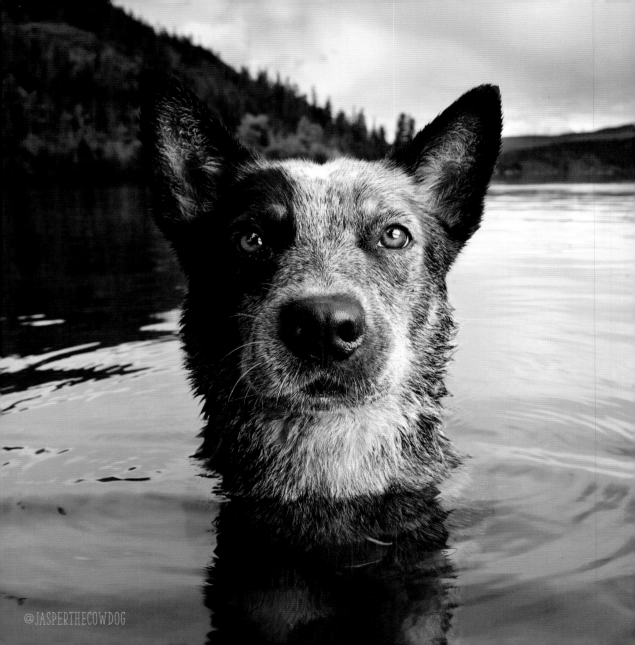

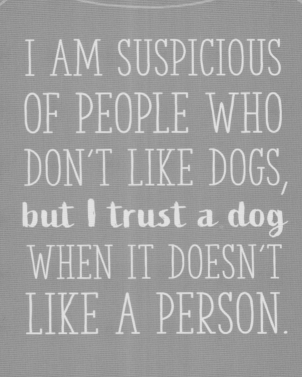

I AM SUSPICIOUS
OF PEOPLE WHO
DON'T LIKE DOGS,
but I trust a dog
WHEN IT DOESN'T
LIKE A PERSON.

-UNKNOWN

IF A DOG WILL NOT
COME TO YOU
AFTER HAVING LOOKED
YOU IN THE FACE,
YOU SHOULD GO HOME
AND EXAMINE
YOUR CONSCIENCE.

-WOODROW WILSON, UNITED STATES PRESIDENT

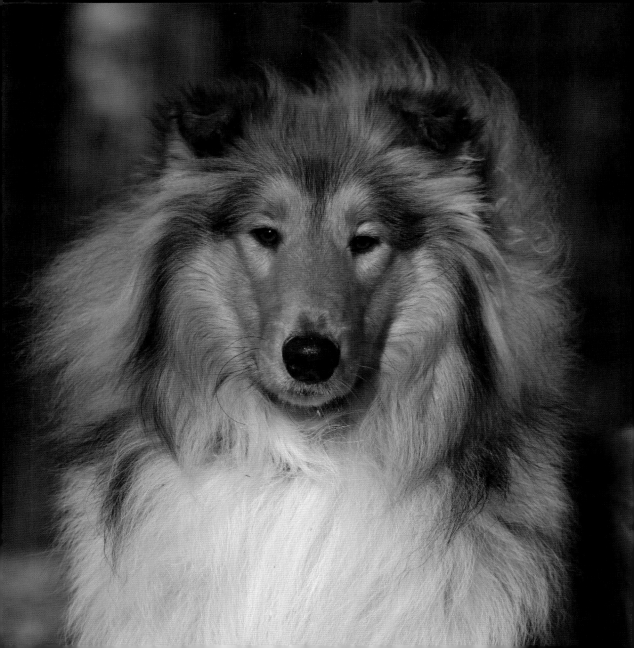

DOGS VS. CATS

There are two types of people in the world: dog people and cat people. In my own experience, these two categories can determine human compatibility faster than sports team preferences, age, or even native language. If two dog people meet, they have an instant connection based on—if nothing else—their love of dogs and their loathing of cats.

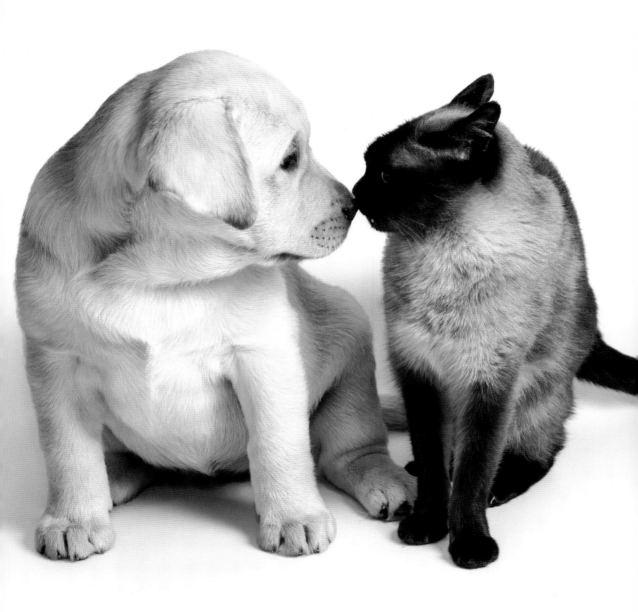

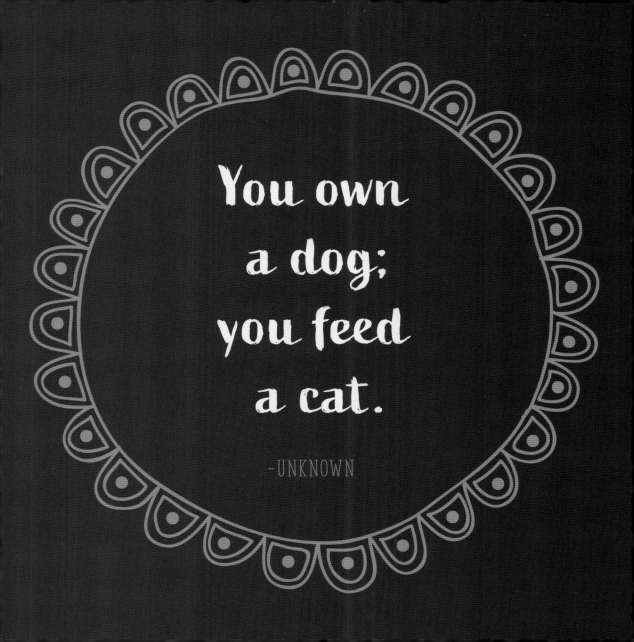

You own
a dog;
you feed
a cat.

-UNKNOWN

MY TRAGEDY IS THAT ALL I WANT IS A DOG, **AND YET I** have been cursed WITH CATS ALL MY LIFE.

-MICHAEL SHEEN, ACTOR

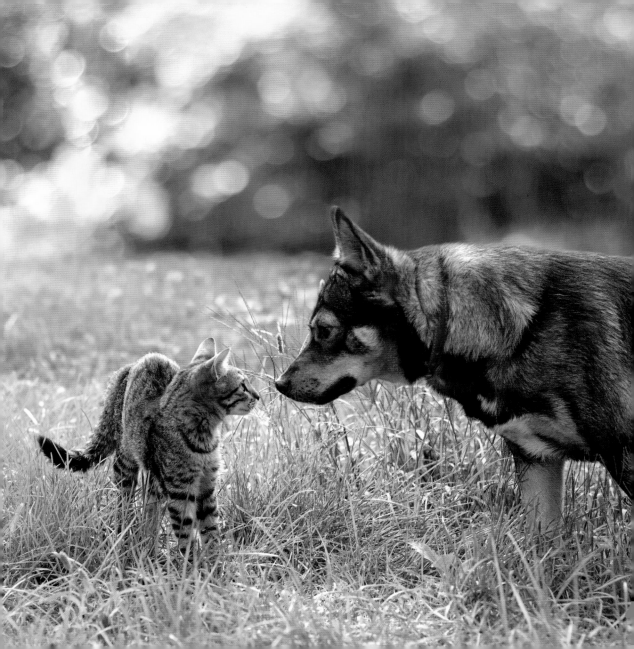

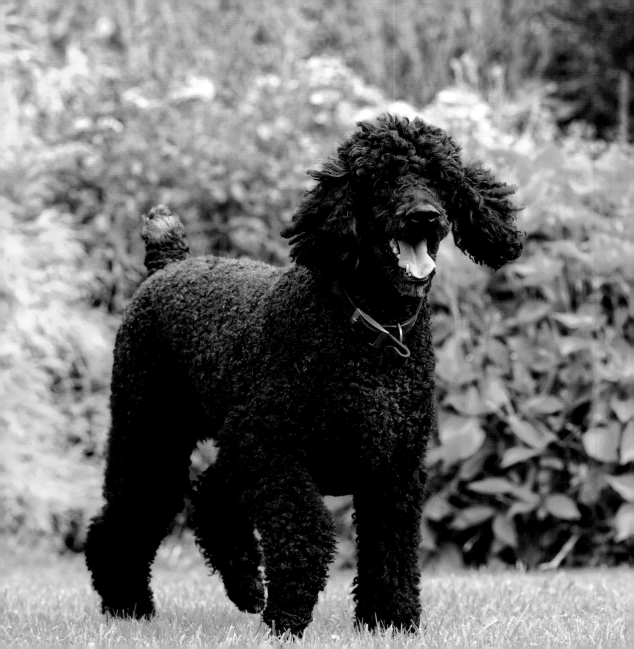

MY CATS

INSPIRE ME DAILY.
THEY INSPIRE ME
TO GET A DOG!

–UNKNOWN

IN ORDER TO KEEP
A TRUE PERSPECTIVE
OF ONE'S IMPORTANCE,
EVERYONE SHOULD HAVE A DOG
THAT WILL WORSHIP HIM
AND A CAT THAT WILL IGNORE HIM.

-UNKNOWN

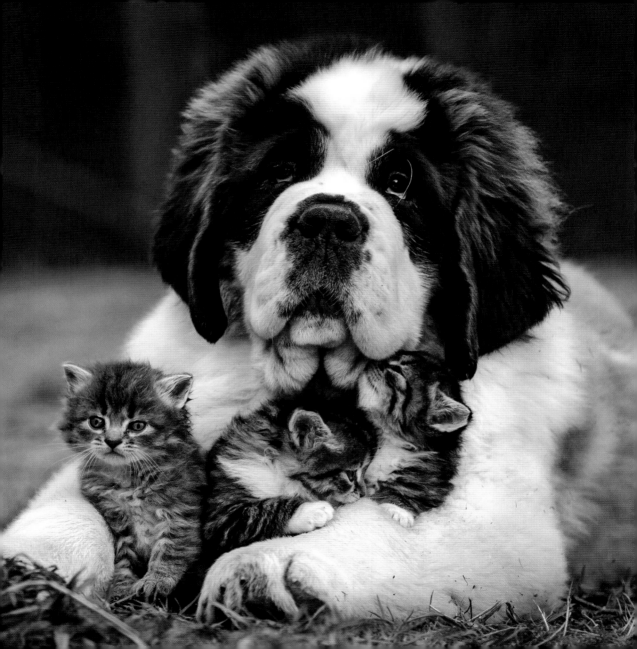

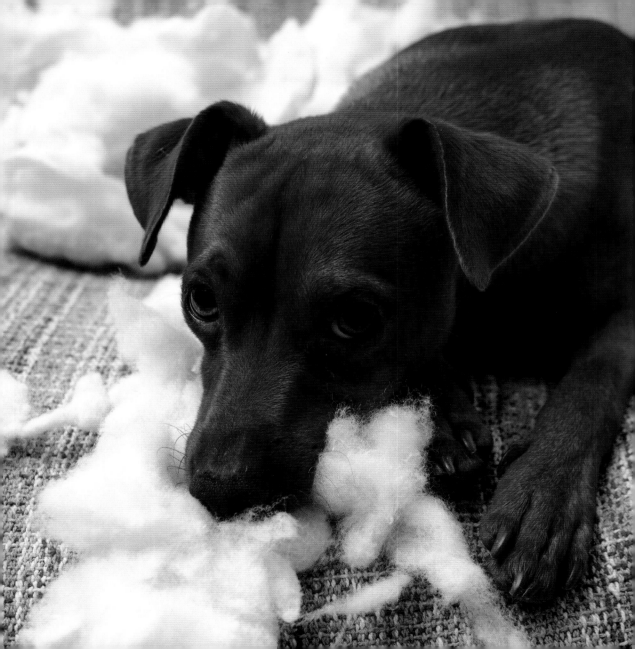

CAT'S MOTTO:
NO MATTER WHAT YOU'VE DONE WRONG, ALWAYS TRY TO MAKE IT
LOOK LIKE
the dog did it.

-UNKNOWN

DOGS WILL GIVE YOU
UNCONDITIONAL LOVE
UNTIL THE DAY THEY DIE.
CATS WILL MAKE YOU
PAY FOR EVERY MISTAKE
YOU'VE EVER MADE
SINCE THE DAY YOU WERE BORN.

-OLIVER GASPIRTZ, AUTHOR AND CARTOONIST

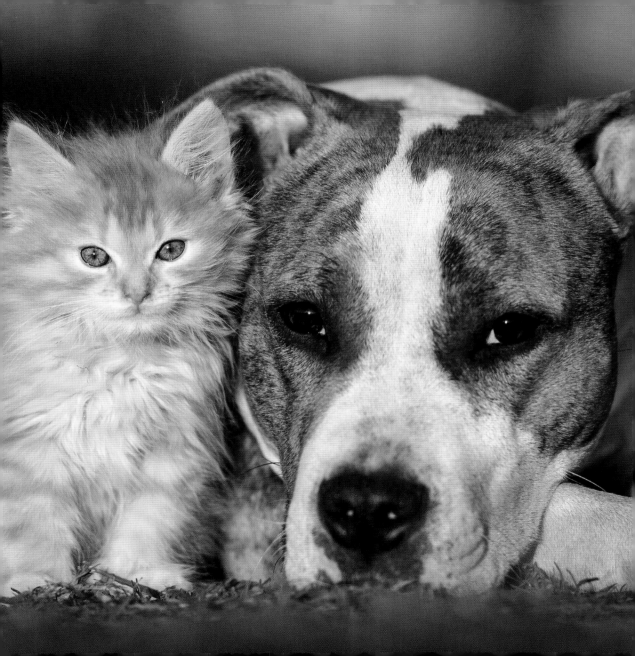

WHO'S TRAINING WHO?

As dog owners, we like to think that we're in charge—that we are the masters and that we call the shots. We teach our dogs practical tricks like "sit," "lie down," and "roll over." We pay for our dogs to attend and graduate from obedience class. We reward good behavior with a treat and punish bad behavior with a tap on the nose.

Yes, we really like to think that we're in charge.

In reality, this is just an illusion. After all, who's the one carrying the poop bags during your daily walk?

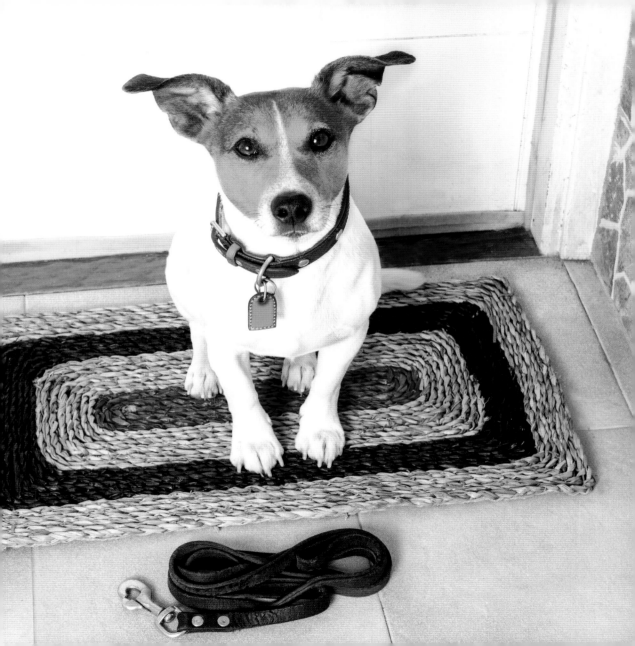

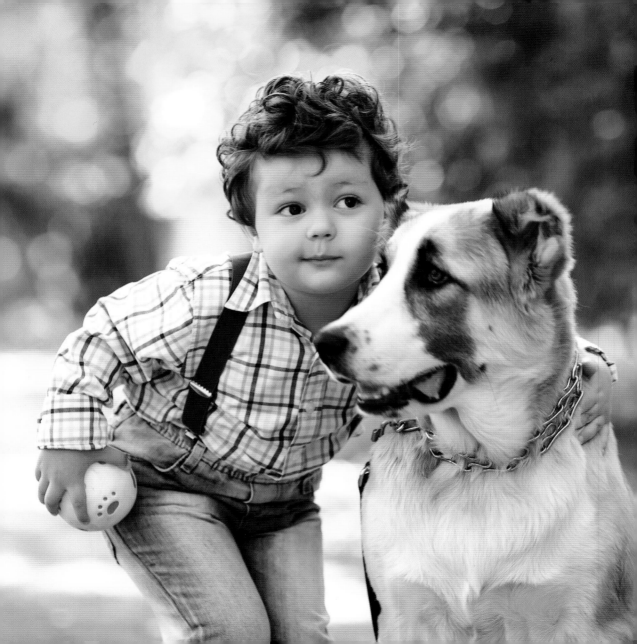

A DOG TEACHES
A BOY FIDELITY,
PERSEVERANCE,
AND TO TURN AROUND
THREE TIMES
BEFORE LYING DOWN.

-ROBERT BENCHLEY, HUMORIST

A DOOR
IS WHAT A DOG
IS PERPETUALLY
ON THE WRONG SIDE OF.

-OGDEN NASH, LIGHT VERSE POET

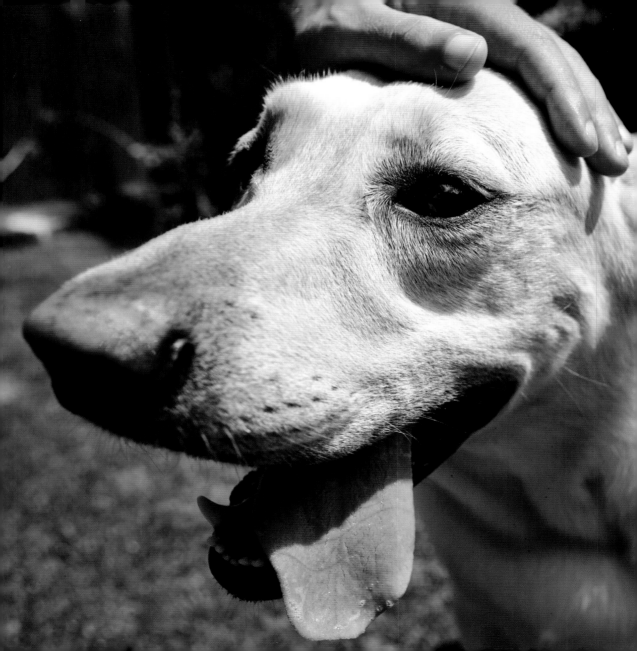

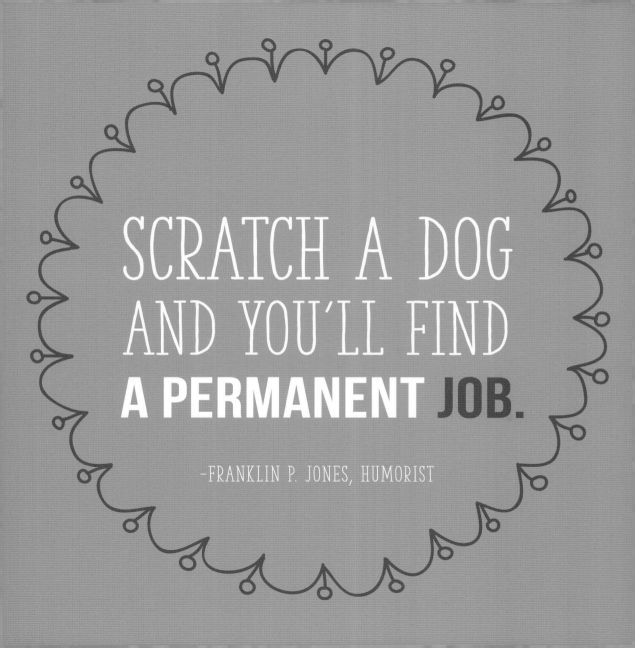

SCRATCH A DOG AND YOU'LL FIND **A PERMANENT** JOB.

-FRANKLIN P. JONES, HUMORIST

WE NEVER
REALLY
OWN A DOG
AS MUCH AS
HE OWNS US.

-GENE HILL,
AUTHOR AND OUTDOORSMAN

If you think
dogs can't count, try
PUTTING THREE DOG BISCUITS
IN YOUR POCKET
AND THEN GIVE HIM
ONLY TWO OF THEM.

-PHIL PASTORET, WRITER

I FEEL SORRY

FOR PEOPLE WHO DON'T HAVE DOGS. I HEAR THEY HAVE TO **PICK UP FOOD** THEY DROP ON THE FLOOR.

-UNKNOWN

BAD DOG

Every dog goes through the "terrible twos," and some never grow out of it. But despite the chewed-up carpets and shoes, the pee puddles in the kitchen, and the inexplicable barking at two o'clock in the morning, it would never even cross your mind to live life without your dog.

Sure, you might complain to yourself as you're replanting the backyard flowers—again—but as soon as someone else mentions the holes in your flowerbed, you jump to your dog's defense.

There's really no such thing as a "bad dog."

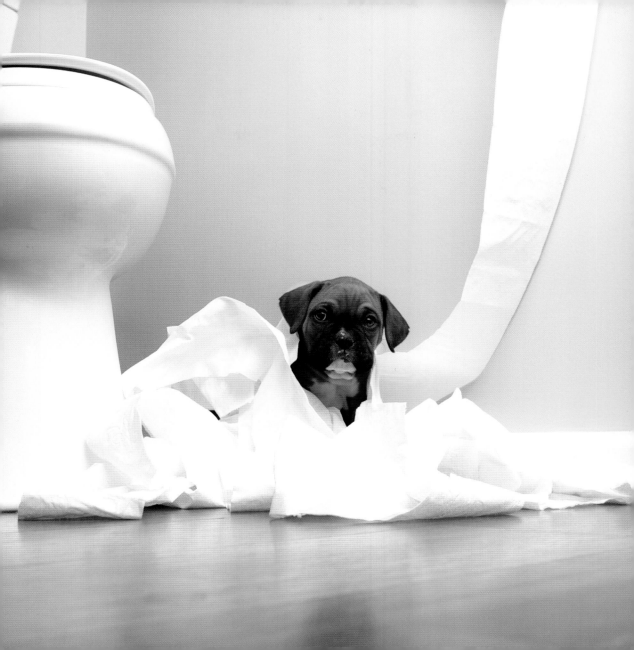

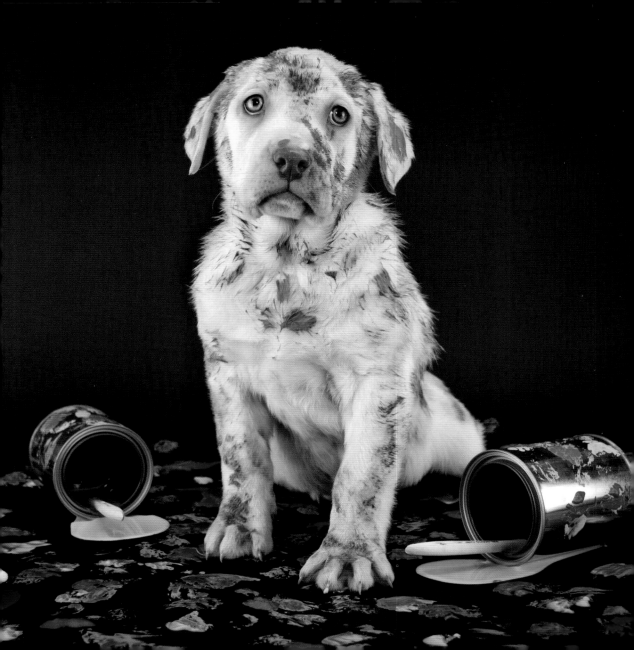

DOGS ARE GREAT.
BAD DOGS, IF YOU CAN
REALLY CALL THEM THAT,
ARE PERHAPS
**THE GREATEST
OF THEM ALL.**

-JOHN GROGAN, AUTHOR, *MARLEY AND ME*

THE MOST
AFFECTIONATE CREATURE
IN THE WORLD
IS A WET DOG.

-AMBROSE BIERCE, SATIRIST AND AUTHOR

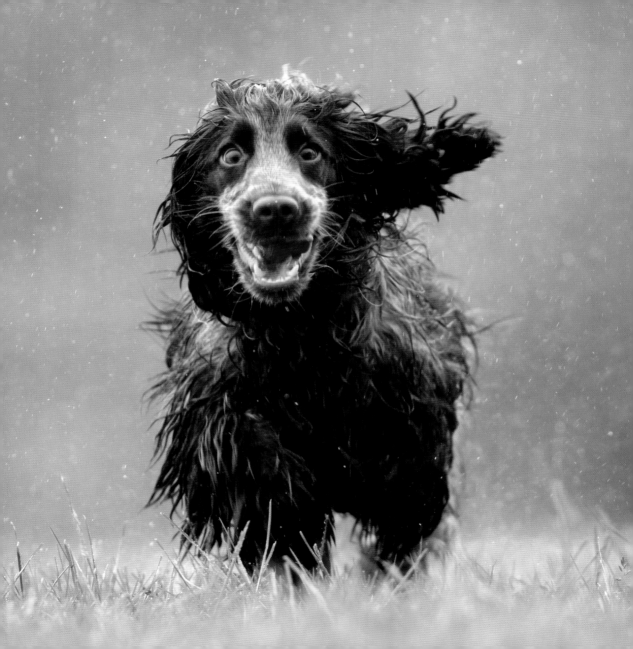

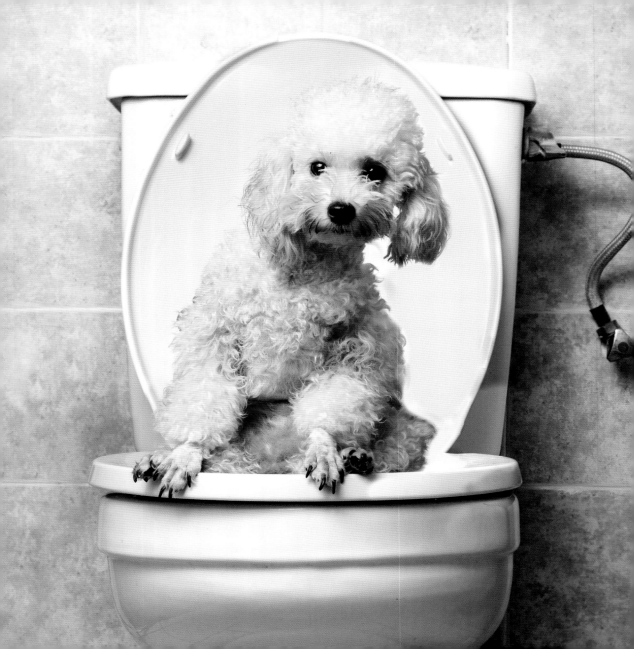

IF YOU DON'T WANT
YOUR DOG TO HAVE
bad breath,
DO WHAT I DO:
POUR A LITTLE
LAVORIS IN
THE TOILET.

-JAY LENO, COMEDIAN AND TV HOST

Dogs feel very strongly that they should always go with you in the car, in case the need should arise for them to bark violently at nothing right in your ear.

–DAVE BARRY, JOURNALIST

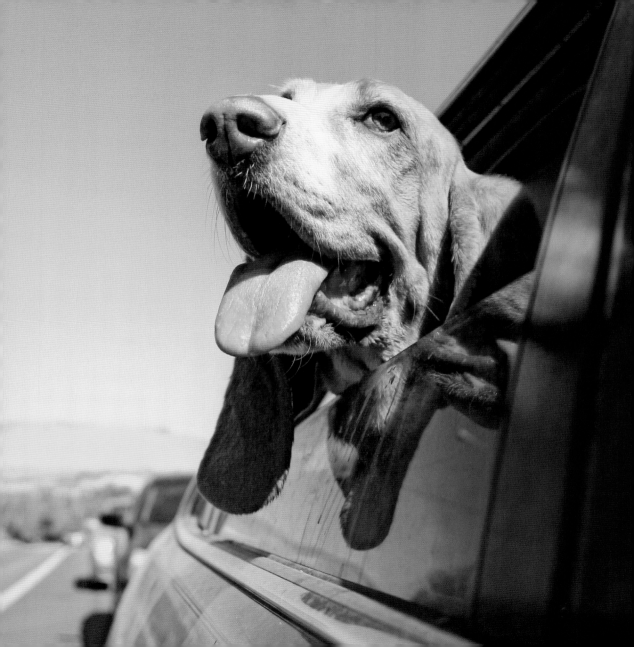

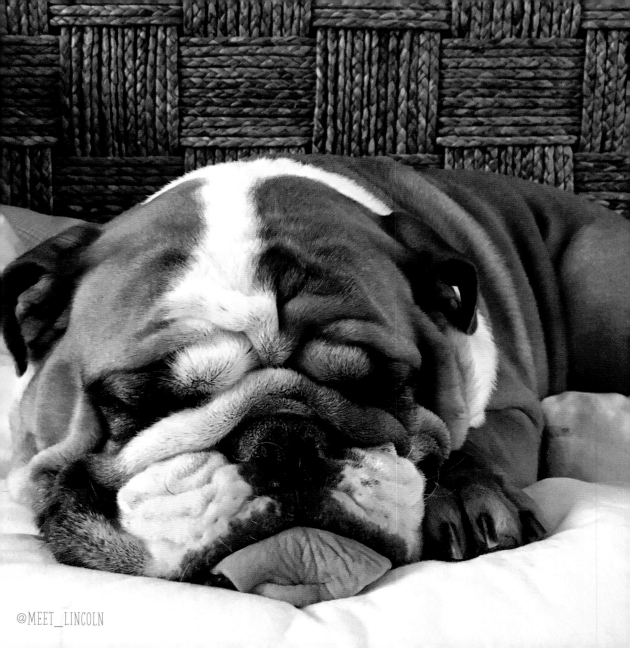

@MEET_LINCOLN

A WATCHDOG IS A DOG KEPT TO GUARD YOUR HOME, USUALLY BY SLEEPING WHERE A BURGLAR WOULD AWAKEN THE HOUSEHOLD BY FALLING OVER HIM.

-ANONYMOUS

The thing I like most about dogs is their absolute belief in their own innocence, even when they've been caught red-handed. No matter what they've been doing, every bad dog bears the same look when scolded: "What?"

-CRAIG WILSON, COLUMNIST AND AUTHOR

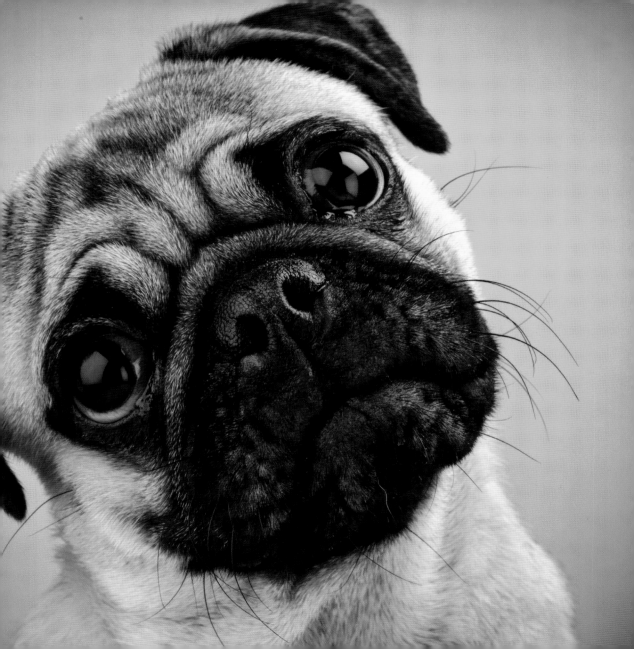

SIMPLE JOYS

Wouldn't it be nice if we could all live our lives the way a dog does? They have the ability to see the world as a place filled with love, adventure, and endless amounts of fun. Every day is a blessing to them, and they express their appreciation with the happy wag of their tails.

If only we could be as grateful, openly honest, loving, and able live in the moment as our dogs. Our lives and the lives of those around us would benefit, just as we benefit from our dogs.

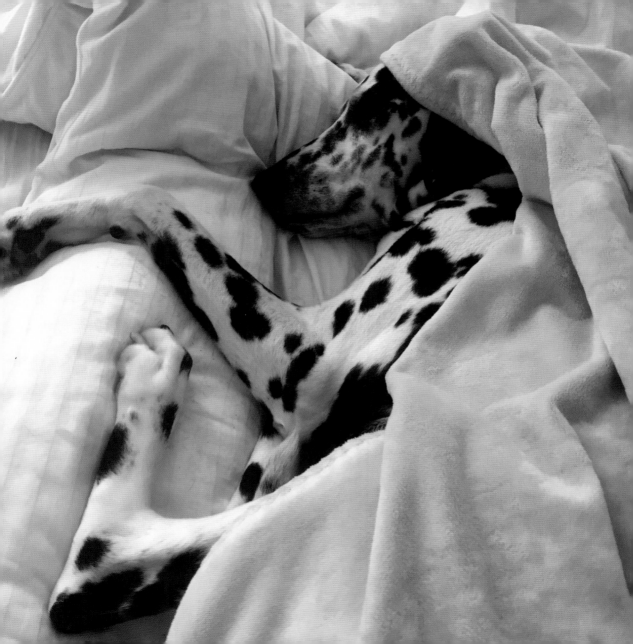

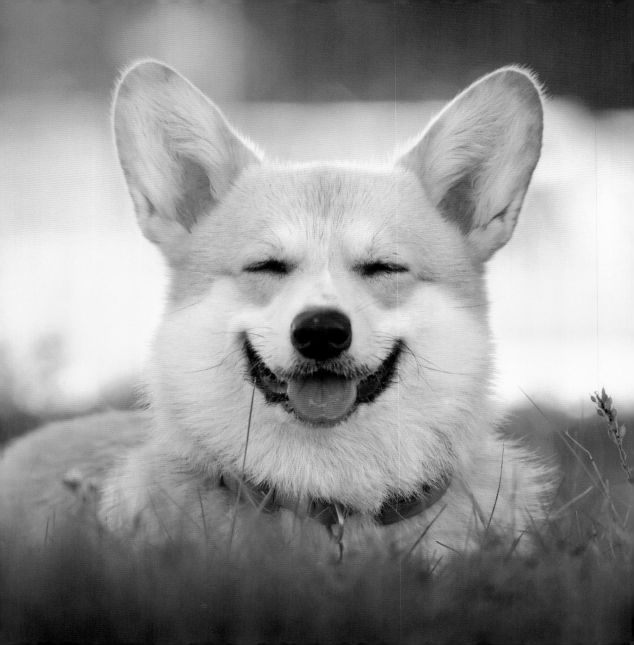

Dogs are often happier

THAN MEN SIMPLY BECAUSE

THE SIMPLEST THINGS

ARE THE GREATEST THINGS

FOR THEM!

-MEHMET MURAT ILDAN, PLAYWRIGHT AND NOVELIST

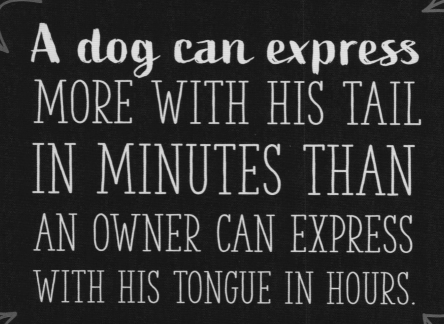

A dog can express
MORE WITH HIS TAIL
IN MINUTES THAN
AN OWNER CAN EXPRESS
WITH HIS TONGUE IN HOURS.

-KAREN DAVISON, AUTHOR

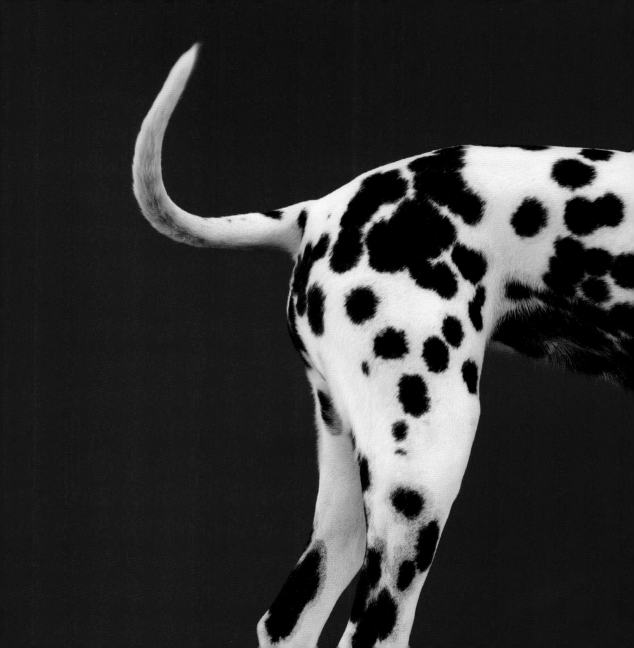

I THINK DOGS ARE THE MOST **AMAZING CREATURES;** THEY GIVE UNCONDITIONAL LOVE. FOR ME THEY ARE **THE ROLE MODEL FOR BEING ALIVE.**

-GILDA RADNER, COMEDIAN AND ACTRESS

Petting, scratching, and cuddling a dog could be as soothing to the mind and heart as deep meditation and almost as good for the soul as prayer.

—DEAN KOONTZ, AUTHOR

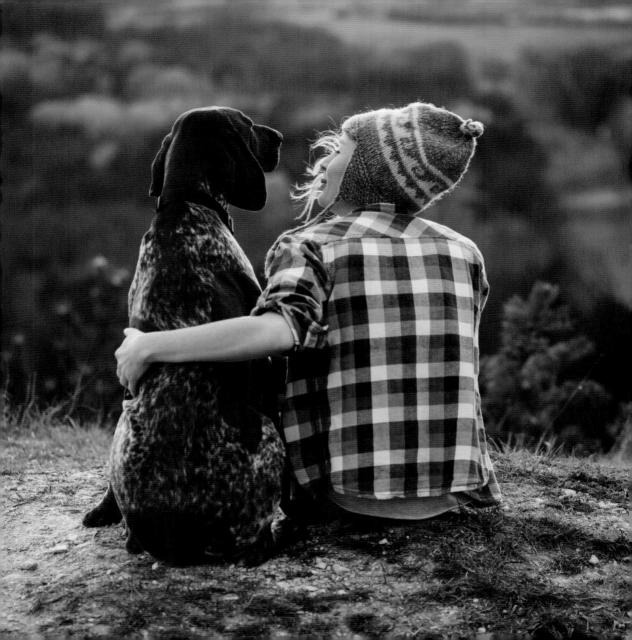

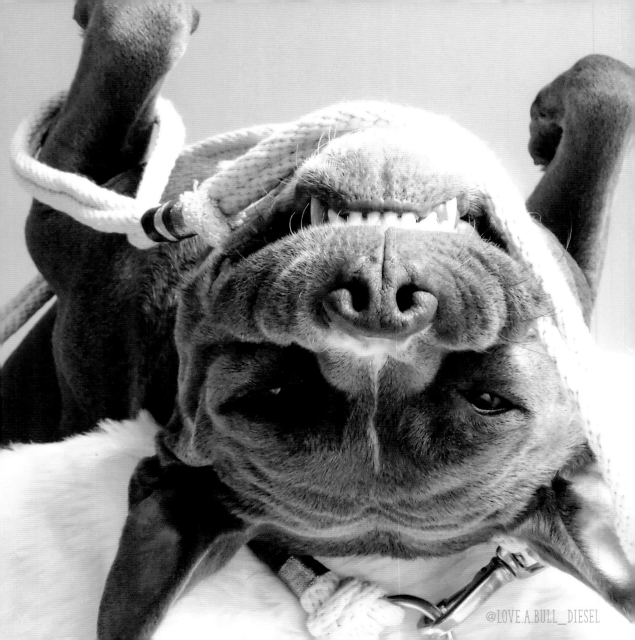
@LOVE.A.BULL_DIESEL

YOU KNOW, A DOG
CAN SNAP YOU OUT
OF ANY KIND OF
BAD MOOD
THAT YOU'RE IN
FASTER THAN YOU
CAN THINK OF.

-JILL ABRAMSON, AUTHOR AND JOURNALIST

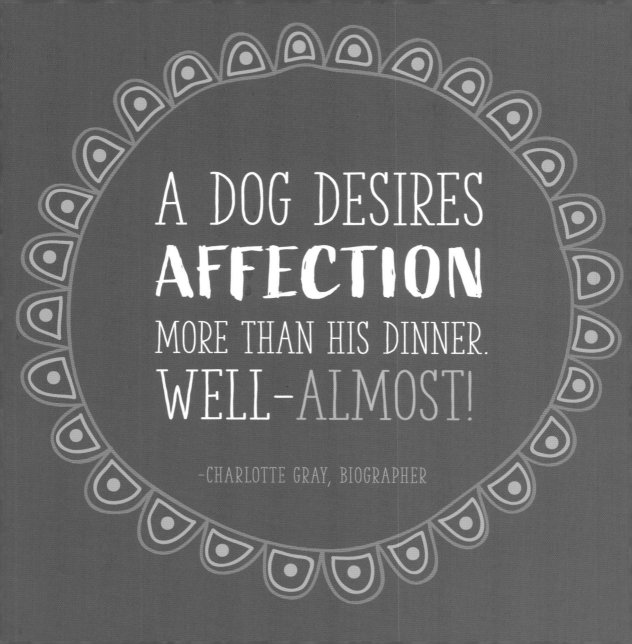

A DOG DESIRES
AFFECTION
MORE THAN HIS DINNER.
WELL–ALMOST!

–CHARLOTTE GRAY, BIOGRAPHER

THE DOG
LIVES FOR
THE DAY,
THE HOUR,
EVEN THE
MOMENT.

–ROBERT FALCON SCOTT, EXPLORER

ALL DOGS GO TO HEAVEN

They say that one human year is the equivalent of seven dog years, so our time with these four-legged blessings will always feel too short. Never take for granted a single day you have with your dog, and when the time comes for you to say goodbye, you'll have memories to help fill the void until you meet again.

Yes, you will meet again. After all, all dogs go to heaven.

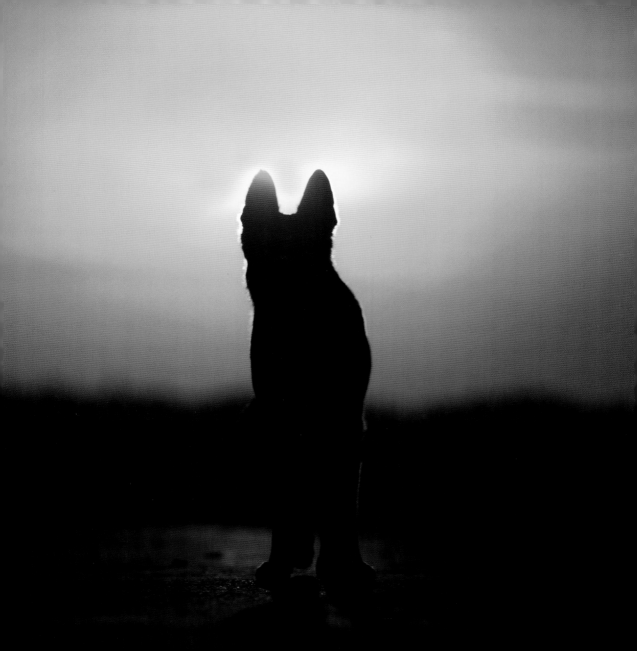

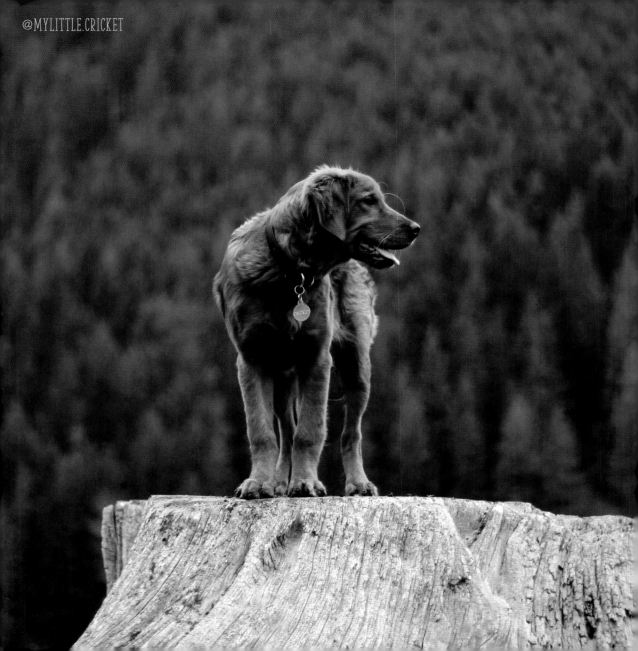

ONCE YOU
HAVE HAD A
wonderful
DOG, A LIFE
WITHOUT
ONE IS A LIFE
diminished.

-DEAN KOONTZ, AUTHOR

One of the happiest sights in the world comes when a lost dog is reunited with a master he loves. You just haven't seen joy till you have seen that.

-ELDON ROARK, COLUMNIST

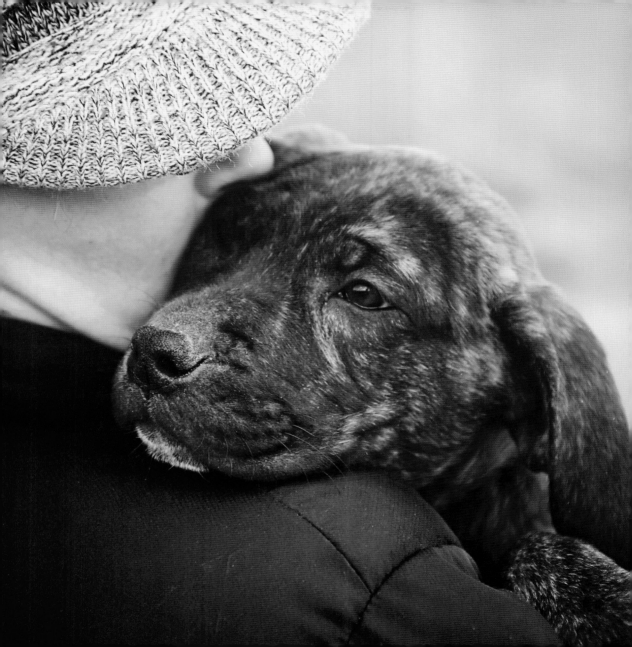

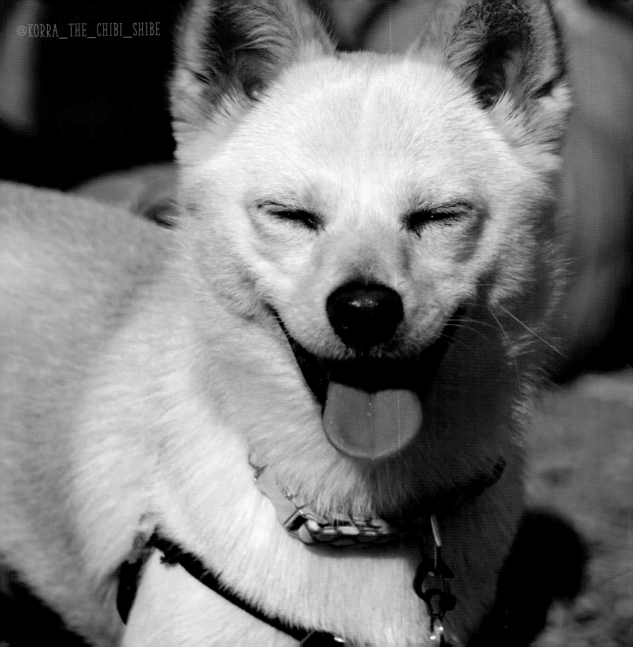

BEFORE YOU GET A DOG, YOU CAN'T QUITE IMAGINE WHAT LIVING WITH ONE **MIGHT BE LIKE;** AFTERWARD, YOU CAN'T IMAGINE LIVING ANY OTHER WAY.

—CAROLINE KNAPP,
WRITER AND COLUMNIST

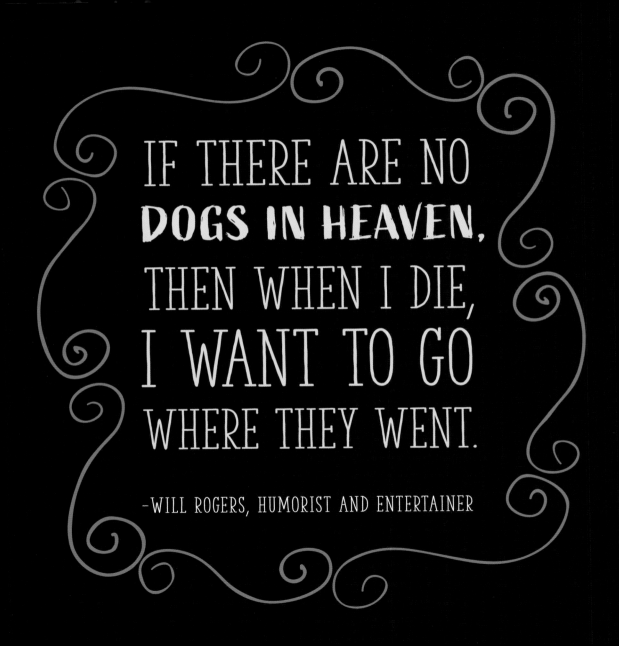

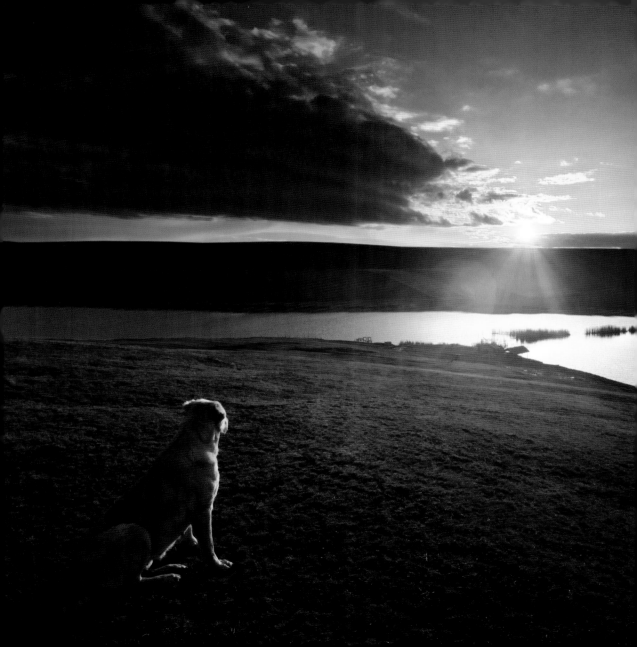

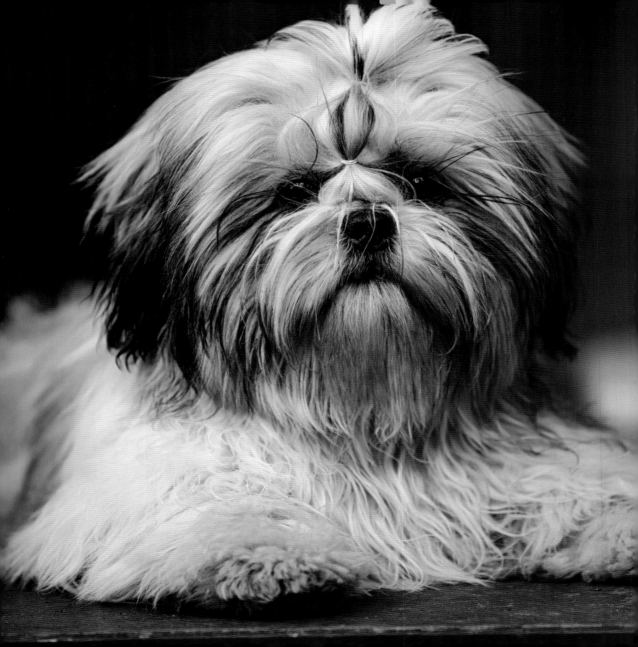

I GUESS YOU DON'T REALLY OWN A DOG; YOU RENT THEM, AND YOU HAVE TO BE THANKFUL THAT YOU had a long lease.

-JOE GARAGIOLA,
BASEBALL CATCHER AND SPORTS ANNOUNCER

THE BOND
WITH A DOG
IS AS LASTING
AS THE TIES
OF THIS EARTH
WILL EVER BE.

-KONRAD LORENZ, ZOOLOGIST AND ETHOLOGIST

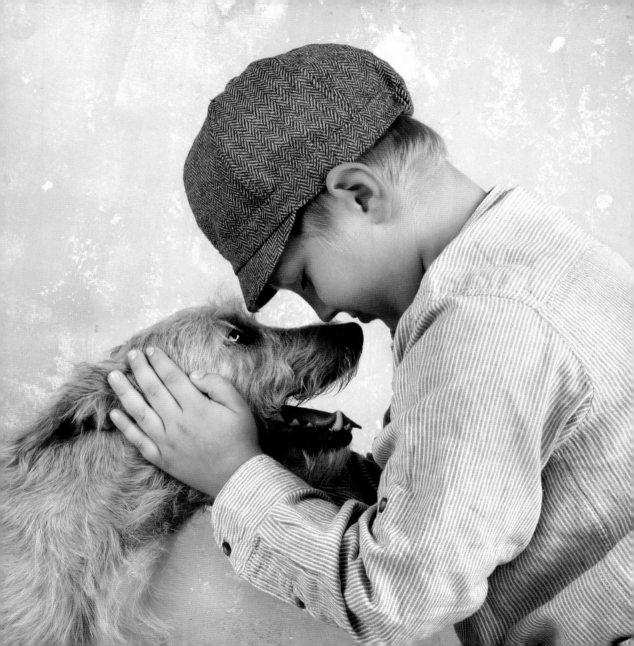

LOVE AND LOYALTY

The number of occupations available to a dog is proof of both their high intelligence and their desire to protect and please humankind. We trust Police K9 Units with our safety, search-and-rescue dogs with our lives, and therapy dogs with our happiness.

But the most important job a dog can do is to be a part of our family, because that is when we trust them with our love. As with their other jobs, they are overqualified for the position. When you love a dog, you never have to worry about rejection, disappointment, or abandonment because they will *always* love you in return.

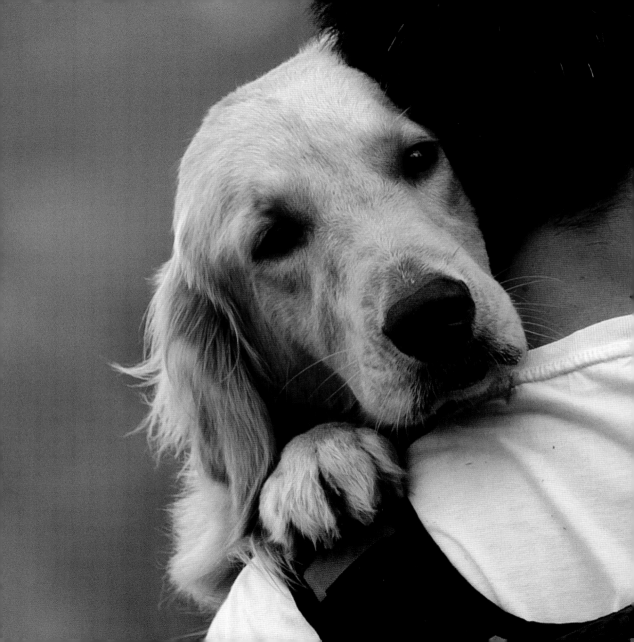

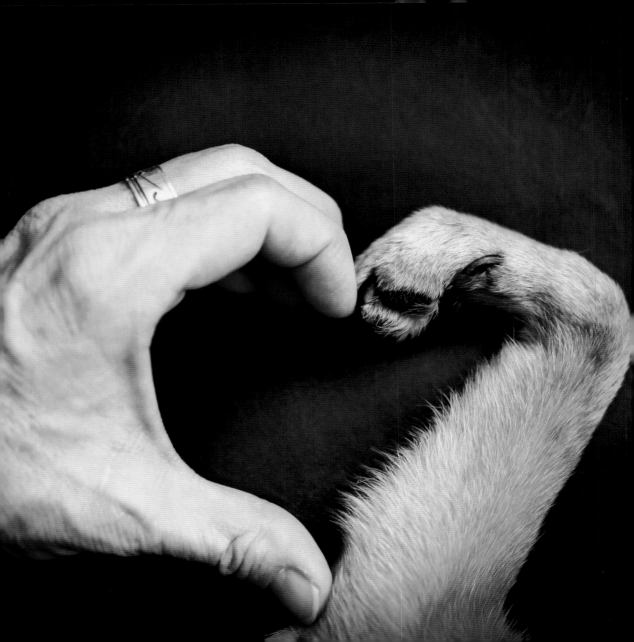

DID YOU KNOW THAT THERE ARE OVER THREE HUNDRED WORDS FOR "LOVE" IN CANINE?

-GABRIELLE ZEVIN, NOVELIST

DOGS JUST NEED YOU and love— THAT'S ALL.

-JENNIFER WESTFELDT, ACTRESS

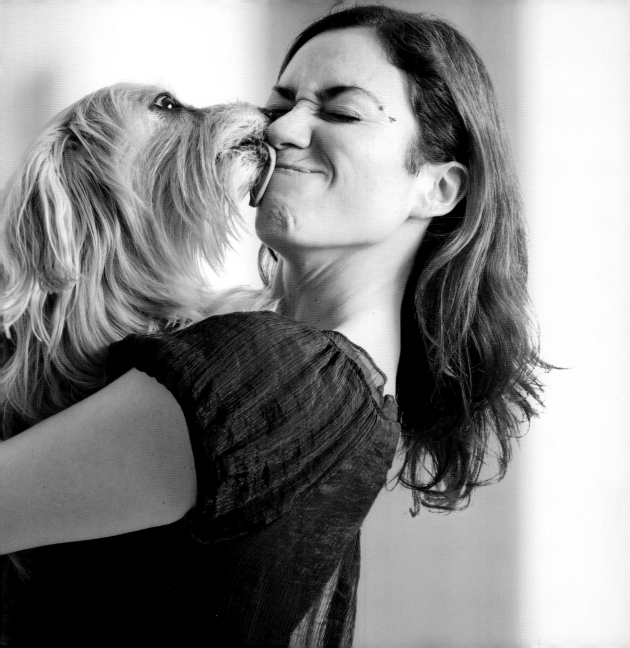

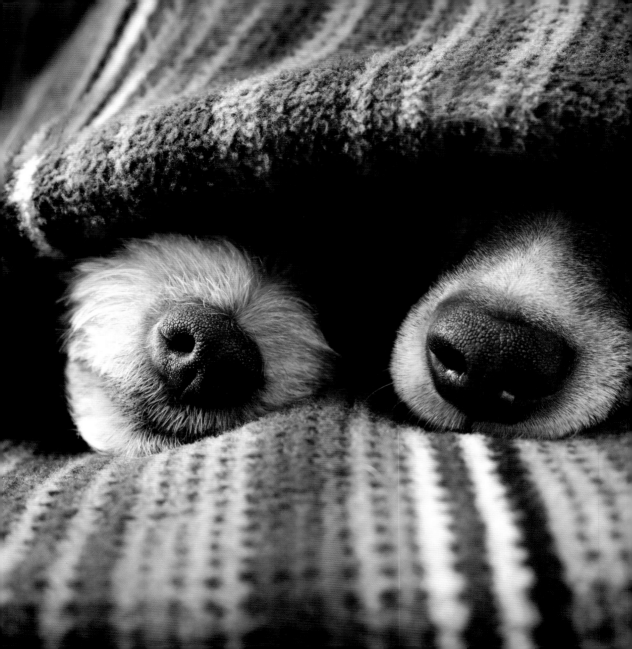

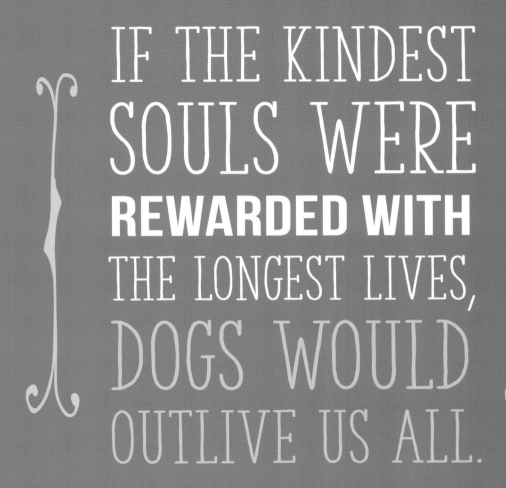

IF THE KINDEST
SOULS WERE
REWARDED WITH
THE LONGEST LIVES,
DOGS WOULD
OUTLIVE US ALL.

–UNKNOWN

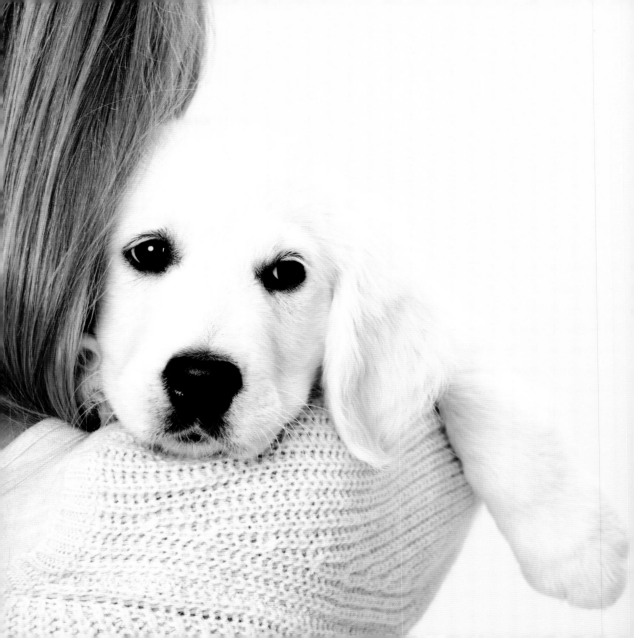

TO ERR IS
HUMAN—
TO FORGIVE,
canine.

-UNKNOWN

IF I COULD BE **HALF THE PERSON** MY DOG IS, I'D BE TWICE THE HUMAN I AM.

-CHARLES YU, AUTHOR AND SCREENWRITER

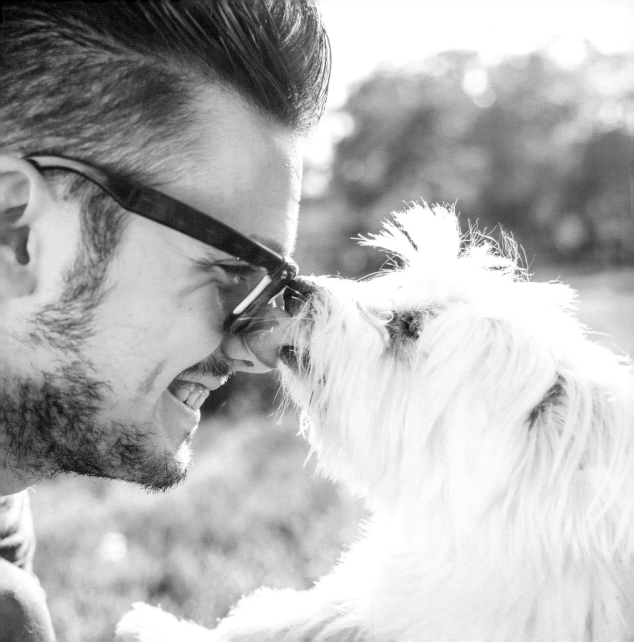

ABOUT
THE AUTHOR

Erika Sargent was raised on the stage singing, dancing, and acting. Combining her love for imagination, expression, and words, she graduated from BYU with a BA in communications (advertising emphasis) and an English minor. Over the past 10 years, she's put her degree to work in retail marketing and, of course, creative writing. She and her husband are proud parents to two fur babies: an Australian cattle dog mix, Darcie, and an Aussiedoodle, Bjorn.

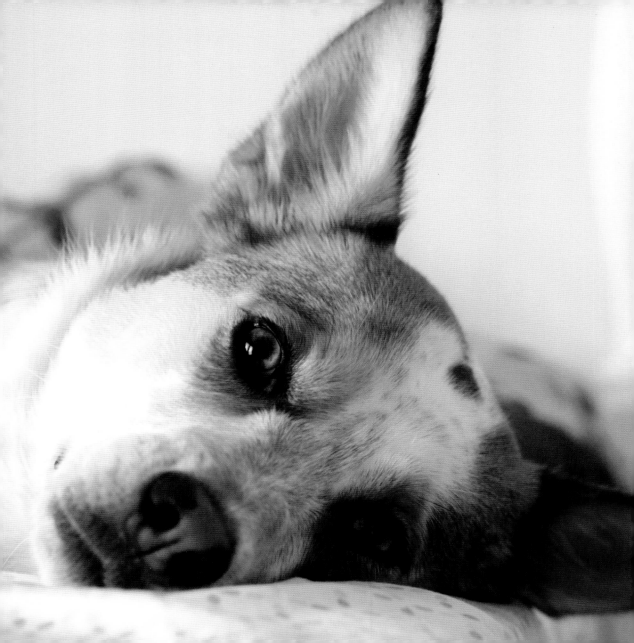

ABOUT FAMILIUS

Familius is a book publisher dedicated to helping families be happy. We believe that the family is the fundamental unit of society and that happy families are the foundation of a happy life. The greatest work anyone will ever do will be within the walls of his or her own home. And we don't mean vacuuming! We recognize that every family looks different and passionately believe in helping all families find greater joy, whatever their situation. To that end, we publish beautiful books that help families live our 9 Habits of Happy Family Life: Love Together, Play Together, Learn Together, Work Together, Talk Together, Heal Together, Read Together, Eat Together, Laugh Together

FAMILIUS

Website: www.familius.com
Facebook: www.facebook.com/paterfamilius
Twitter: @familiustalk, @paterfamilius1
Pinterest: www.pinterest.com/familius